Lighthouse Series

THE GOLDEN AGE OF AMERICAN LIGHTHOUSES

A Nostalgic Look at U.S. Lights from 1850 to 1939

TIM HARRISON AND RAY JONES

The Globe Pequot Press

GUILFORD, CONNECTICUT

For my biggest fan, my mother, Dorothy Harrison, and my son T.J., and my grandson, Tyler
—Timothy Harrison

For my wonderful friends, Rona Halpern and Harvey Brodsky
—Ray Jones

Page design by Nancy Freeborn

Library of Congress Cataloging-in-Publication Data

Harrison, Tim.
 The golden age of American lighthouses : a nostalgic look at U.S. lights from 1850 to 1939 / Tim Harrison and Ray Jones.
 p. cm.
 ISBN 0-7627-1276-7
 1. Lighthouses—United States—History. I. Jones, Ray, 1948– II. Title.

VK1023.H3698 2002
387.1'55'0973—dc21 2002016350

Manufactured in the United States of America
First Edition/First Printing

CONTENTS

PREFACE

THIS UNIQUE PICTORIAL CHRONICLE brings to life a century of American lighthouse history with hundreds of archival photographs, many of them never before published. It tells the often dramatic story of America's lighthouses from the middle of the nineteenth century until shortly before World War II, an era many believe was the "golden age" of American Lighthouses. What made this classic period so bright and memorable? Turn to the pages of this book for the answer.

Lighthouse fans are familiar with their favorite lighthouses as they look today but, perhaps, not as they appeared during the nineteenth or early twentieth century. This book is filled with vintage black-and-white views of classic towers such as those at Boston Harbor, Cape Hatteras, Grosse Point in Illinois, and Alcatraz Island in San Francisco Bay. It also focuses on the work life and day-to-day existence of lighthouse keepers and their families. Many portraits of old-time keepers and key lighthouse personalities are included.

The antique images faithfully reproduced here came from many sources. Some were pulled from the voluminous files of the U.S. Coast Guard and the National Archives, while others were borrowed from museums or local lighthouse organizations. A few photos came from dusty trunks found in the attics of former lighthouse keepers or from family albums of their children.

If you are a lighthouse buff, or one of the countless other Americans who cherish our nation's history and look to lighthouses as beacons of time and of the human spirit, *The Golden Age of American Lighthouses* will be a rewarding and enlightening window to the past.

Chapter 1

A CLASSIC ERA

The Golden Age and How It Began

EVERY FORM OF HUMAN ENTERPRISE has passed through a halcyon epoch fondly remembered as a "golden age." Christopher Columbus discovered America during the golden age of exploration. Charles Darwin proposed his theory of evolution during the golden age of science. Civilization itself had a golden age—the classical period when ancient Greece and Rome reached their zenith.

U.S. maritime history produced its own shining era—a time when bridges of light linked the land to the sea, when bold sea captains steered their vessels without the aid of radar, satellites, or computers, relying instead on bright shore beacons focused by hand-polished glass lenses. It was a time when grizzled keepers maintained lonely navigational stations often so remote that they were visited only once or twice a year by government supply ships. It was a time of tall ships and even taller light towers, a time that might very well be called the golden age of lighthouses.

America's first lighthouse was built in 1716 on Little Brewster Island near the entrance to Boston Harbor. A few other colonial lights were established at Brant Point (1746) on Nantucket, Beavertail (1749) in Rhode Island, New London Harbor (1760) in Connecticut, Sandy Hook (1764) in New Jersey, and elsewhere along the coast of what would become the United States. Following the Revolution and the establishment of a constitutional union, the federal government assumed control of these early American lighthouses and made plans for construction of more.

At first, the work of marking the nation's coasts moved slowly, but by the middle of the nineteenth century, the United States could boast several hundred lighthouses. Unfortunately, many of these structures were of poor quality, and their light signals, powered by outmoded lamp-and-reflector systems, were nearly always inadequate. Mariners complained bitterly that some American beacons were worse than useless and actually caused more shipwrecks than they prevented.

The problem lay, not with the government's commitment to safe navigation nor with the keepers—most of whom worked hard and were dedicated to saving ships and lives—but rather with the way the nation's lighthouses were administered. For more than thirty

years, beginning in 1820, all U.S. navigational lights came under the authority of the Treasury Department's fifth auditor, a career bureaucrat named Stephen J. Pleasonton. As parsimonious as he was autocratic, Pleasonton negotiated such tightfisted construction contracts that lighthouse builders were forced to scrimp on materials. Many of the towers built during his reign as general superintendent of lighthouses (an informal title) began to crumble and fall apart after only a few years. What was worse, for decades Pleasonton resisted adoption of Fresnel lenses and other improvements that could have made U.S. navigational beacons vastly more effective. As a result, American lighthouses were inferior and far less useful to navigators than those in Britain and some other maritime nations.

However, all this began to change, and change quickly, after Pleasonton lost his grip on what had come to be called the "Lighthouse Establishment." His downfall was due in part to a series of disastrous shipwrecks, hurricanes, and other calamities during the 1840s that focused increased attention on maritime safety. A comprehensive government report completed in 1851 proved highly critical of Pleasonton, and the following year authority over U.S. lighthouses passed to an appointed board consisting of military officers, maritime experts, and engineers.

Almost immediately, the new Lighthouse Board, headed by its chairman, Admiral William B. Shubrick, launched a large-scale effort to upgrade the nation's entire system of navigational aids. Weathered towers were repaired, unsound structures were torn down and replaced, and many new light stations were established. Screw-pile, caisson, and iron skeleton construction techniques were used to build lighthouses where they would be most useful—directly over shoals and at key offshore turning points. Hundreds of Fresnel lenses were imported from France to brighten beacons along every U.S. coastline. In short, America's golden age of lighthouses had begun. It was destined to last for nearly a century, in fact, right up until World War II, when political necessity and the advance of navigational technology brought it to a close.

Each of the following chapters examines a different aspect of lighthouses during the golden age, a period from about 1850 to 1939. You'll see images of American navigational stations as they appeared at about the time this era began; you'll take a look at the construction techniques, lenses, foghorns, and machinery that made the age possible; you'll meet the men, women, and children who made lighthouses their homes and worked together to keep the lights burning; you'll see some of America's best-known lighthouses and learn how those venerable towers changed over the years. And finally, you'll read about the sad but inevitable conclusion of this classic era in America's maritime history.

Join us now as we journey through time and along America's coasts from Maine to Alaska, to see and experience the golden age of American lighthouses.

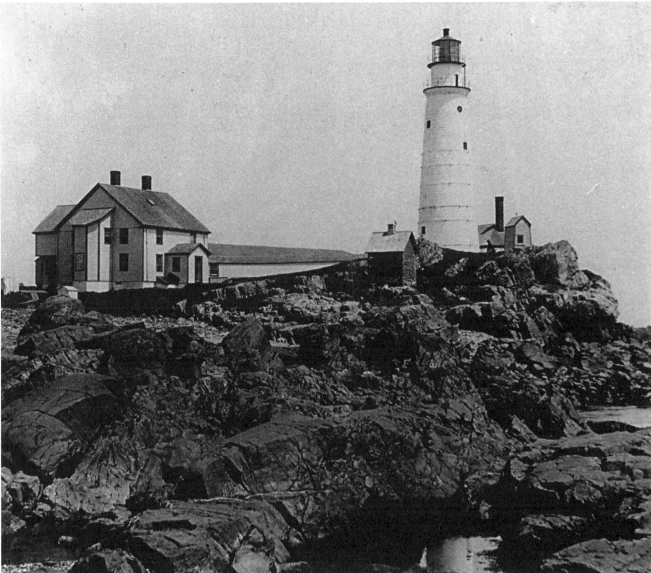

AMERICA'S FIRST LIGHT STATION was established in 1716 on Little Brewster Island near the entrance to Boston Harbor, but the tower shown here is not the nation's oldest. Blown up by British troops as they retreated from Boston during the Revolutionary War, the original stone tower was rebuilt in 1783. This photograph shows the station as it appeared during the nineteenth century.

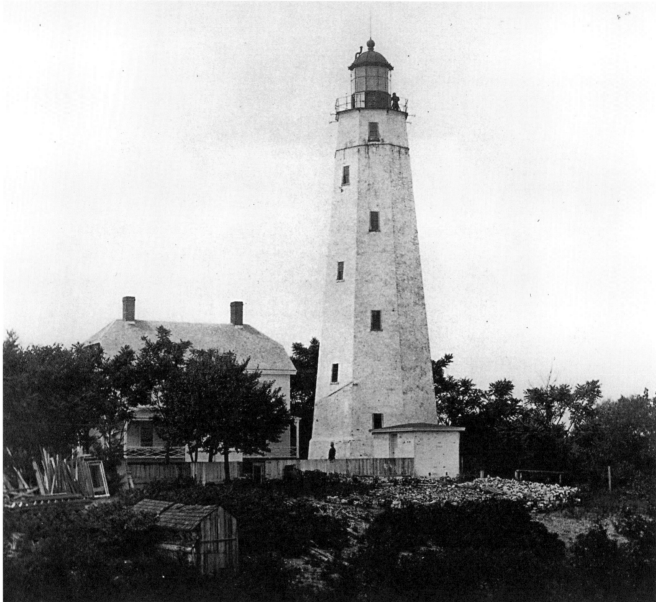

NATIONAL ARCHIVES

ALREADY A CENTENARIAN when this photograph was taken more than a hundred years ago, the octagonal rubblestone tower on New Jersey's Sandy Hook is the nation's oldest standing lighthouse. Established in 1764, the Sandy Hook Light Station came under attack during the Revolutionary War, but unlike those at the Boston Harbor Lighthouse, the original structures survived. Ironically, the 1776 assault on Sandy Hook was launched, not by the British, but by Continental soldiers, who hoped to keep the strategic lighthouse out of the hands of the Royal Navy. The Continental cannonballs made barely a dent in the 6-foot-thick tower walls, and the patriots were soon forced to retreat. As a result, the lighthouse continued to guide mariners and still does so today, even though it is older than the republic it serves.

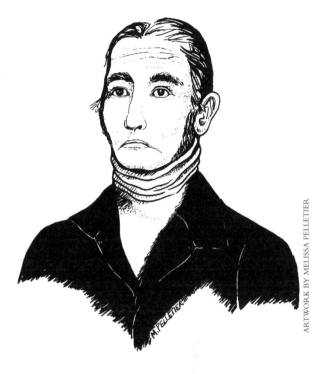

ARTWORK BY MELISSA PELLETIER

A PEN-AND-INK LIKENESS of Treasury Fifth Auditor Stephen J. Pleasonton depicts him with the dour expression of a man who often boasted of his penny-pinching ways. Placed in charge of U.S. lighthouses in 1820, Pleasonton proved an overzealous guardian of public funds who resisted improvements and innovations. Some blame him for the backwardness and inefficiency of America's early navigational aids. Despite his many drawbacks as "general superintendent of lighthouses" (his informal title), however, Pleasonton left the nation an astounding legacy. As a young clerk serving in Washington during the War of 1812, he managed to rescue a sizable cache of historic documents from the British when they captured and burned the Capitol. Pleasonton loaded the documents onto a wagon and hauled them to a farmhouse near Leesburg, Virginia, where they were stored until the danger had passed. Among the items he saved were the original copies of the Declaration of Independence and the Constitution of the United States.

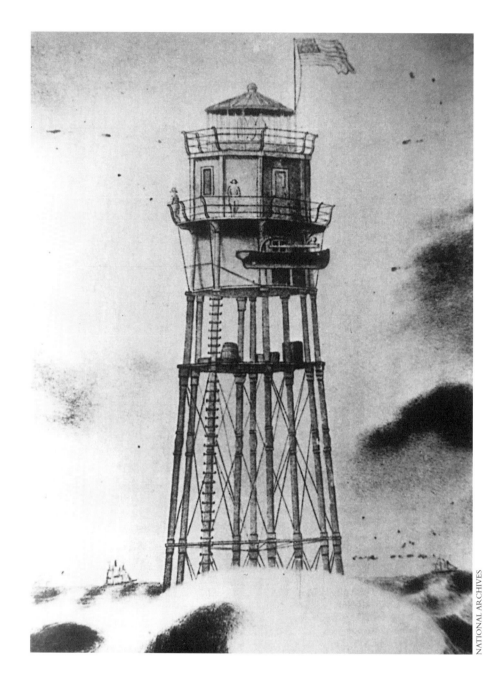

A SERIES OF SHIPWRECKS AND OTHER CALAMITIES undermined confidence in Pleasonton and his minimum budget approach to administering the nation's lighthouses. Among the most widely publicized of these mishaps was the collapse of the Minot's Ledge Lighthouse. Perhaps the most innovative project completed during Pleasonton's thirty-two-year reign as general superintendent, the Minot's Ledge tower stood on iron legs anchored to a wave-swept rock off Cohasset, Massachusetts. In 1851, little more than a year after it was completed, the tower collapsed in a heavy gale, killing two assistant keepers.

ADMIRAL WILLIAM B. SHUBRICK

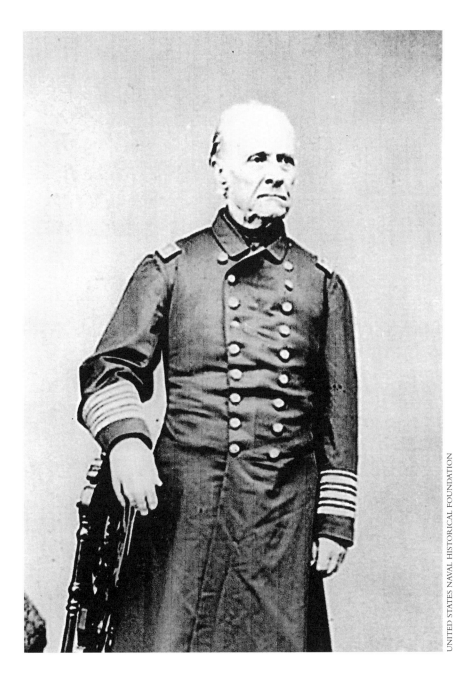

UNITED STATES NAVAL HISTORICAL FOUNDATION

IN 1852 CONGRESS TOOK RESPONSIBILITY FOR U.S. NAVIGATIONAL AIDS away from Pleasonton and passed it to a nine-member Lighthouse Board composed of civilian maritime authorities, engineers, and military men. Admiral William B. Shubrick, a widely respected naval officer, was named chairman, a position he held for nearly twenty years. Admiral Shubrick's Lighthouse Board brought new energy and professionalism to the federal Lighthouse Establishment, which eventually came to be known as the U.S. Lighthouse Service. For nearly half a century the service operated under the overall guidance of Shubrick and his successors on the Lighthouse Board.

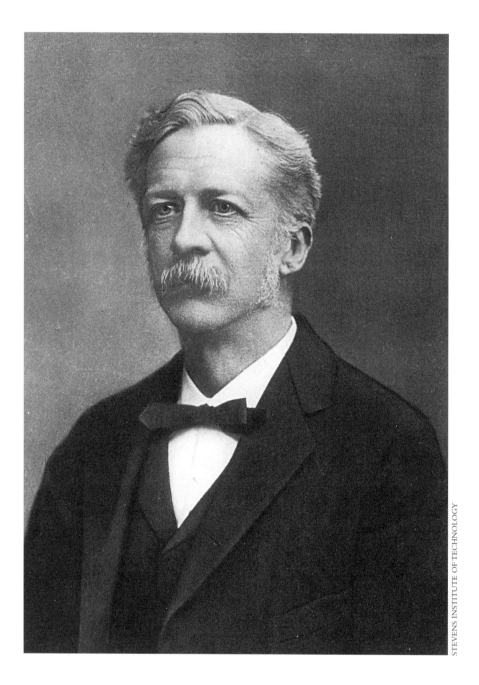

STEVENS INSTITUTE OF TECHNOLOGY

AN EARLY CIVILIAN MEMBER OF THE LIGHTHOUSE BOARD was Henry Morton, founder of the American Society of Mechanical Engineers and president of the Stevens Institute of Technology in Hoboken, New Jersey.

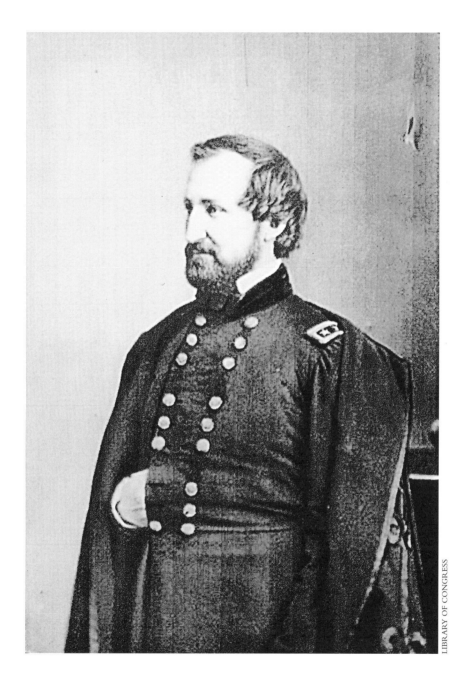

LIBRARY OF CONGRESS

EXCEPT FOR A TWIST OF FATE, lighthouse engineer William S. Rosecrans might have been president of the United States. One of several highly talented civil engineers employed by Admiral Shubrick's Lighthouse Board, Rosecrans was a West Point graduate. During the Civil War, he became a Union general and fought with such distinction that Abraham Lincoln offered him the nomination for vice president on the 1864 Republican ticket. A lifelong Democrat, Rosecrans hesitated, and by the time he telegraphed his acceptance, Lincoln was already committed to Andrew Johnson. Had Rosecrans answered immediately, he would have become president after Lincoln's assassination in 1865.

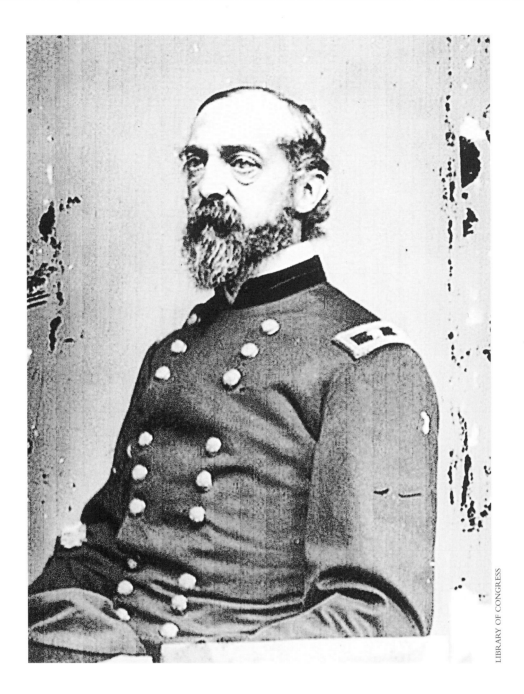

LIBRARY OF CONGRESS

AMONG THE IMPORTANT CIVIL WAR GENERALS who once served under Shubrick was George Gordon Meade, most widely known as the Union commander who defeated Robert E. Lee at Gettysburg. Before the war, Meade made a much more peaceful contribution to his country in the form of sturdy light towers, many of which still stand. Ironically, Meade built most of his lighthouses in the South.

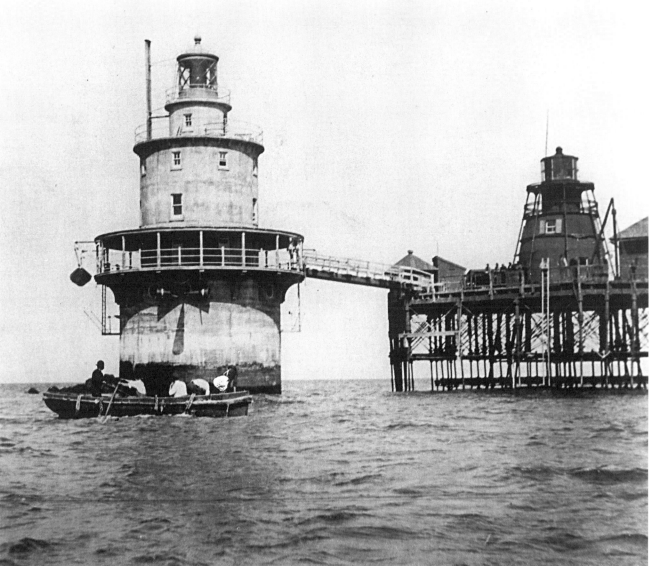

THESE TWO LIGHT TOWERS AT BRANDYWINE SHOAL in Delaware Bay illustrate the innovative spirit that enlivened American engineers during the middle of the nineteenth century and continued to inspire generations of lighthouse builders. After several earlier attempts to mark this vicious navigational obstacle had failed, George Meade helped design the unique screw-pile structure on the right. Supported by a forest of bladed iron piles screwed deep into the mud at the bottom of the bay, the tower served for more than sixty years. Finally, it was replaced in 1914 by the structure on the left built atop a massive caisson—another construction technique pioneered by Lighthouse Board engineers.

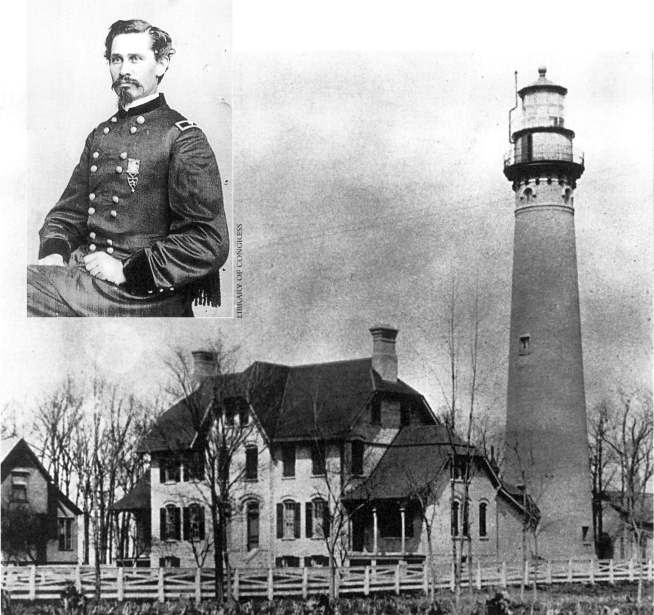

LIBRARY OF CONGRESS

LIGHTHOUSE DIGEST ARCHIVES

ANOTHER LIGHTHOUSE BUILDER WHO FOUGHT IN THE CIVIL WAR was Orlando Poe, chief engineer for General William T. Sherman during the Union invasion of Georgia. Sherman placed Poe in charge of burning the city of Atlanta following its capture in April 1864. After the war, Poe applied his skills to more constructive pursuits, and he built a number of lighthouses in the Great Lakes region. Among these was the magnificent Grosse Point Lighthouse in Illinois, completed in 1873. The rambling Grosse Point residence and tower reflect the Victorian tastes of the era. These elegant structures still stand.

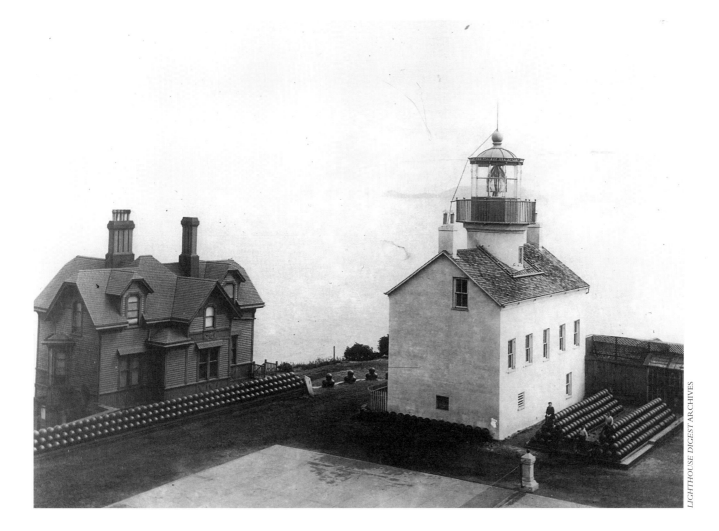

DURING ITS FIRST DECADE, the Lighthouse Board established many new navigational stations, particularly in the West, where the acquisition of California had extended the U.S. shoreline by nearly 1,000 miles. At the head of the long list of western projects undertaken by the board was San Francisco's Alcatraz Island Lighthouse, completed in 1854. As the stacks of artillery ammunition suggest, the combination light tower and keeper's dwelling shared the island with a military base. The lantern room at the top of the tower held a third-order Fresnel lens.

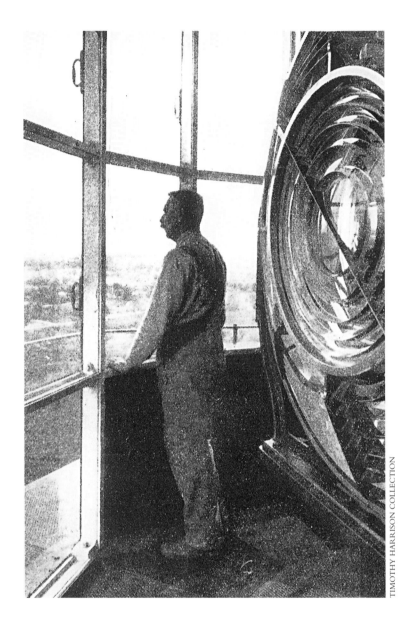

TO INCREASE THE EFFICIENCY AND RANGE OF U.S. BEACONS, the Lighthouse Board imported large numbers of Fresnel lenses. Manufactured in France, these polished glass, prismatic lenses came in a variety of sizes, or "orders." Not much larger than a gallon jug, the sixth-order lenses were the smallest, while the largest standard Fresnels were the giant first-order lenses, some of which were more than 6 feet in diameter. Massive and complex, large Fresnels, like the first-order lens above, consisted of hundreds of individual glass prisms arranged in a heavy brass frame.

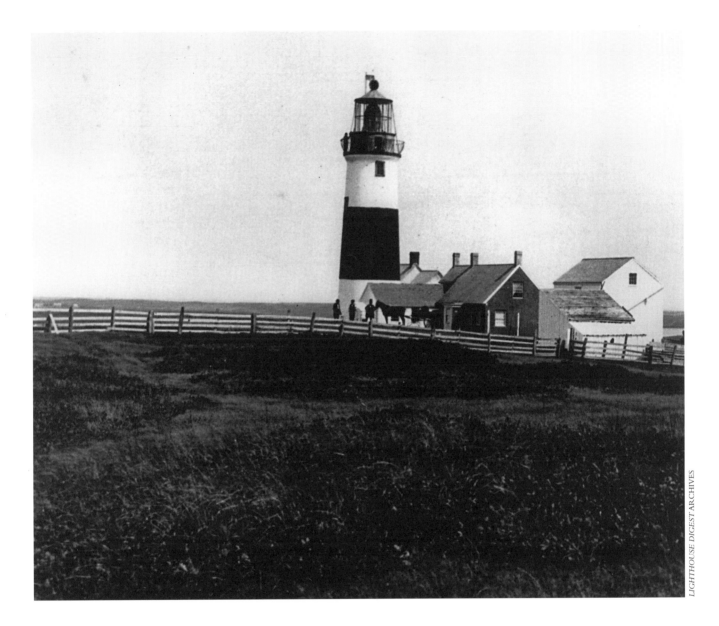

LIGHTHOUSE DIGEST ARCHIVES

AMONG THE CRITICISMS LEVELED AGAINST PLEASANTON had been his reluctance to make use of the superior lenses invented by Augustin Fresnel during the 1820s. Completed in 1850, the Sankaty Head Lighthouse on Nantucket was one of the first American light stations to receive a Fresnel lens. The huge lens nearly filled the Sankaty lantern room and produced a beacon so bright that sailors described it as a "rocket light" or "bright star."

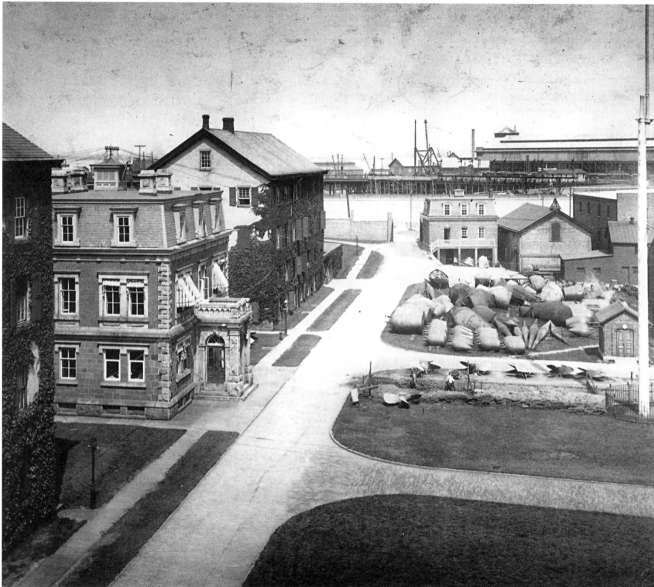

NATIONAL ARCHIVES

A TIGHT-KNIT CIVILIAN AGENCY WITH ITS OWN FLAGS, uniforms, and insignia, the U.S. Lighthouse Service operated and maintained the nation's far-flung system of navigational markers. The service stockpiled materials at depots like this one on Staten Island, New York, once the agency's national base. The building with the stone entryway on the left contained Lighthouse Service and depot offices. The structure still stands and is slated to become the National Lighthouse Museum. Notice the jumble of buoys and channel markers on the right.

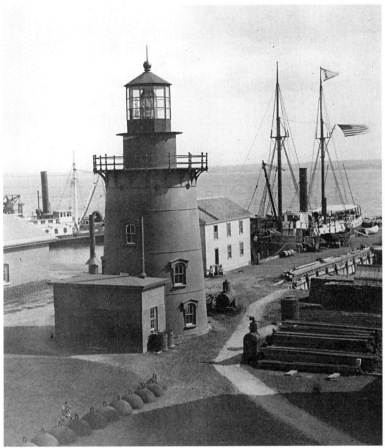

Equipped wth a powerful second-order Fresnel lens, the Staten Island Depot Lighthouse marked the depot's loading docks as well as the approaches to New York City. A pair of steam lighthouse tenders can be seen behind the tower. Flying both the U.S. flag and a Lighthouse Service pennant, the vessel on the right appears to be taking on supplies.

NATIONAL ARCHIVES

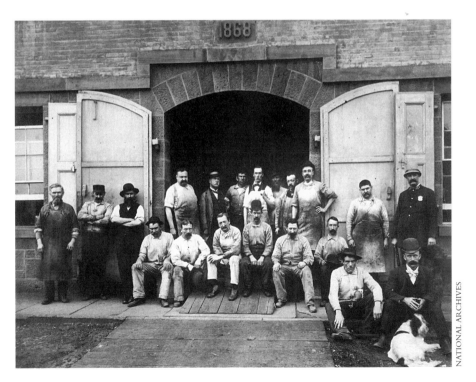

A group of Staten Island Depot workers.

NATIONAL ARCHIVES

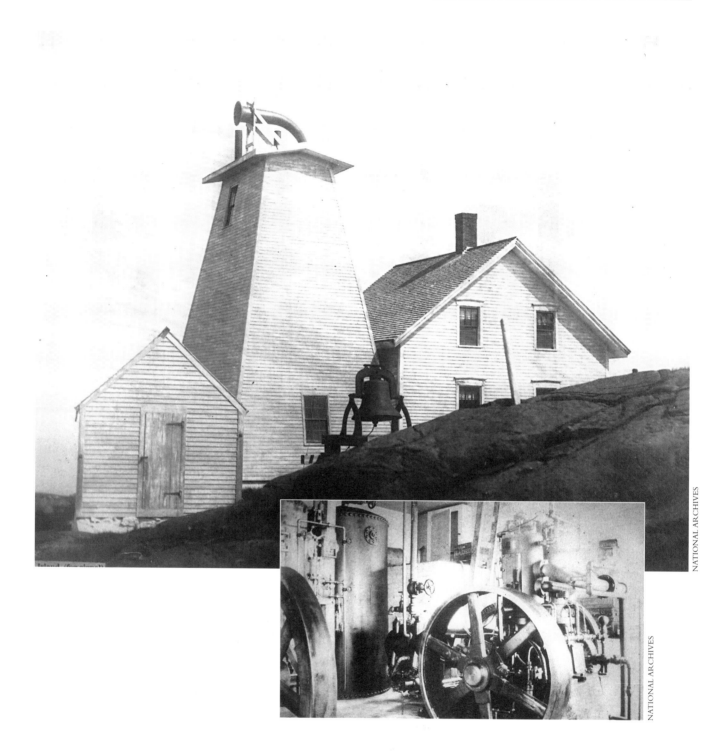

THE LIGHTHOUSE BOARD also developed new steam-powered fog signals like this one on Maine's Manana Island. Many early-nineteenth-century navigational stations warned fog-bound vessels with a bell struck by the keeper. At the time the photograph at top was taken, the Manana Island Station still had its bell—perhaps used in emergencies when fuel ran out or the foghorn boilers were cold.

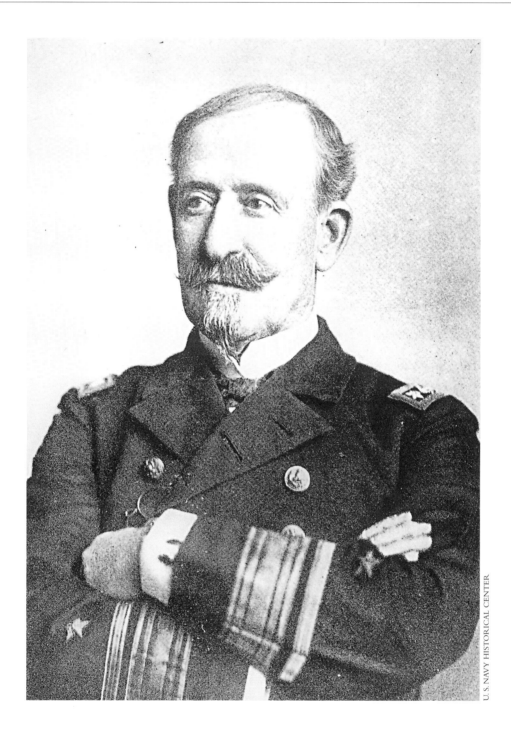

U.S. NAVY HISTORICAL CENTER

IN ADDITION TO PERIODIC DELIVERY OF SUPPLIES sent by way of tender from a lighthouse depot, keepers could expect occasional visits from Lighthouse Service inspectors, who checked everything from the condition of the lens to the cleanliness of the floors and windows in the station residence. Winfield Scott Schley served as an inspector in New England during the 1880s. A Civil War veteran and naval officer, Schley commanded a battle squadron during the Spanish-American War.

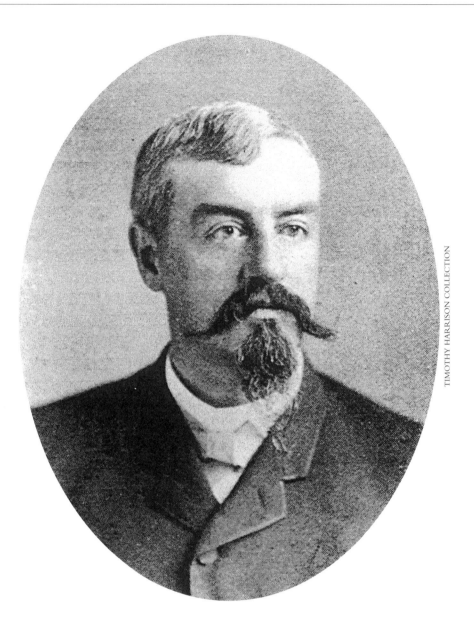

TIMOTHY HARRISON COLLECTION

ANOTHER CIVIL WAR VETERAN, George W. Coffin served as a Lighthouse Service inspector during the 1880s.

PORTLAND HEAD LIGHTHOUSE

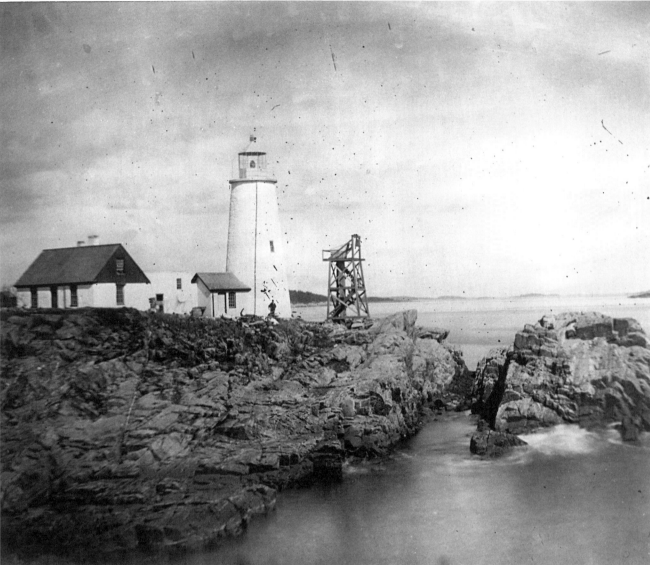

SWEPT BY THE TIDES OF CHANGE FOR MORE THAN 210 YEARS, Maine's Portland Head Light-house has a history roughly paralleling that of the entire U.S. lighthouse system. The first lighthouse completed by the federal government, it dates to 1791. For decades mariners were forced to rely on its relatively weak oil lamps and reflectors to guide them safely into Portland, but key improvements were made during the latter half of the nineteenth century. When this early photograph was taken, in 1858, the fieldstone tower stood at its original height of approximately 80 feet. In an effort to find the most effective height for the beacon, the government raised the tower by 20 feet in 1864, the shortened it by 20 feet in 1883, and then raised it again by 20 feet in 1885.

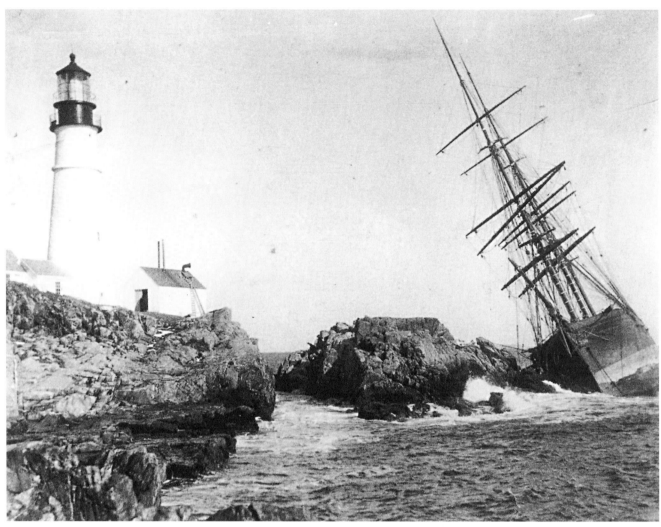

THE ADDITIONAL HEIGHT AND BRIGHT NEW LENS of the Portland Head Lighthouse were not enough to save the *Annie Maguire*, which was lost on nearby rocks in 1886. However, keepers helped save fourteen crew members from the wrecked vessel.

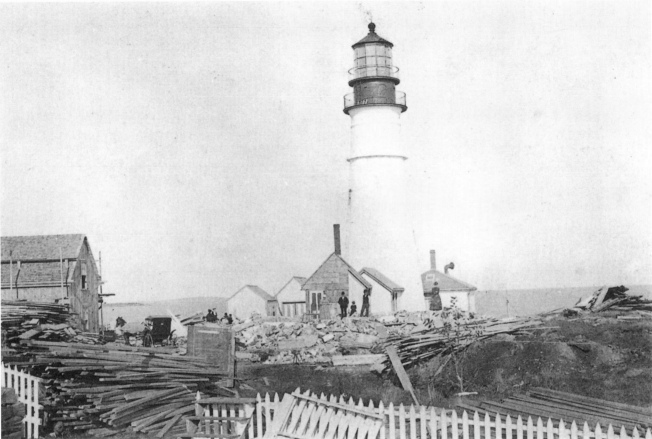

PILES OF LUMBER AND STONE await construction of a spacious new keeper's dwelling at Portland Head. The rambling two-story duplex was completed in 1891.

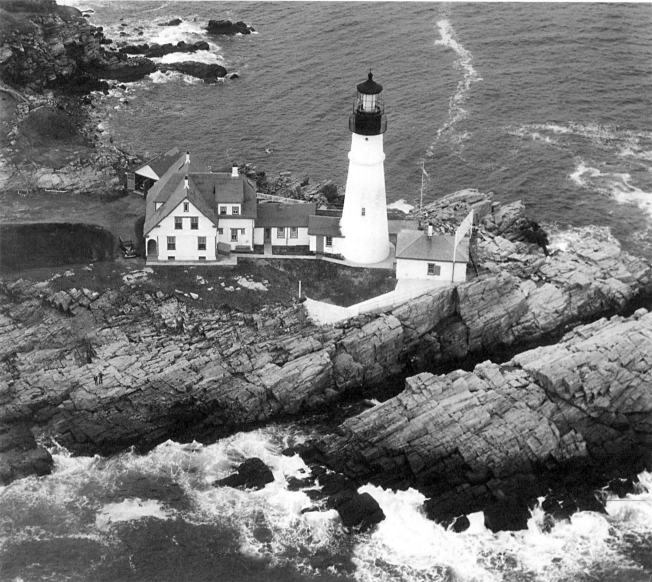

THIS AERIAL VIEW FROM THE LATE 1930s shows Portland Head Lighthouse much as it looks today, with one important exception. The big second-order Fresnel lens seen here in the lantern room at the top of the tower is gone. It was replaced by an aerobeacon in 1958. Full-time keepers occupied the station residence until the light was automated in 1989.

SEVERAL GENERATIONS OF A SINGLE NEW ENGLAND FAMILY made their home at the Portland Head Lighthouse and faithfully tended its beacon. Appointed keeper in 1869, a grizzled sea captain named Joshua Strout began a family tradition that was to last for a century.

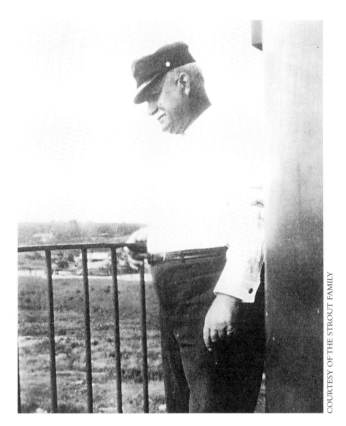

Above: Standing at the top of the tower is Joshua Strout's son Joseph, who spent his entire fifty-one-year working career at Portland Head.

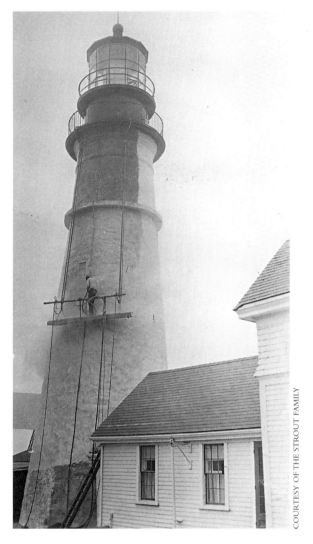

Above: Joseph Strout whitewashing the tower walls during the 1920s.

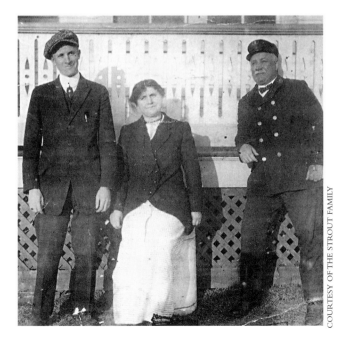

Left: Decked out in his Lighthouse Service uniform, Joseph Strout poses with his wife, Mary, and son John, who would follow him as keeper.

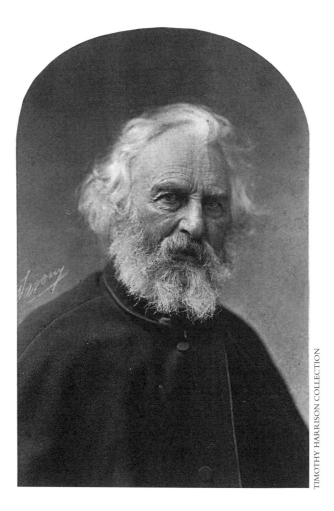

TIMOTHY HARRISON COLLECTION

NINETEENTH-CENTURY POET HENRY WADSWORTH LONGFELLOW often took long walks beside the ocean. His favorite destination was the Portland Head Lighthouse, where he enjoyed lively conversations with Joshua Strout. Longfellow may have had the old stone tower and its keeper in mind when he wrote these words:

> *Steadfast, serene, immovable,*
> *The same year after year,*
> *Through all the silent night,*
> *Burns on forevermore,*
> *That quenchless flame,*
> *Shines on that inextinguishable light!*
> *Sail on! It says, sail on,*
> *Ye stately ships,*
> *And with your floating bridge,*
> *The ocean span:*
> *Be yours to bring man nearer unto man.*

Chapter 2

DAWN LIGHTS

Lighthouses as They Looked at the Beginning of the Golden Age

A MATTER OF OBVIOUS NATIONAL CONCERN, lighting the coasts became one of the very first responsibilities shouldered by the federal government. Having completed the Portland Head Light in 1791, federal authorities moved on to establish light stations in every coastal state. Within a few decades hundreds of wooden and stone towers marked America's shores from Maine to Texas and along the Great Lakes.

These early navigational lights were built and administered in a largely haphazard manner. Politics often determined where a lighthouse would be placed, how much would be spent on its construction, and even who would become its keeper. As a result, each light station was essentially unique, with its own architectural style, equipment, and manner of operation.

The Lighthouse Board created by Congress in 1852 inherited a hodgepodge of more than 250 navigational stations, most of them built and staffed without any uniform standards. Skilled organizers, the engineers and military men appointed to the board introduced industrial age efficiency and Victorian propriety to what had been a chaotic national system of navigational aids.

As that classic era of American lighthouse history emerged, the old-time Lighthouse Establishment that had thrived before 1852 faded and then disappeared. Today, reminders of that early period are extremely rare. A few very old towers remain, but most have been altered repeatedly and no longer look as they did 150 or 200 years ago.

This chapter includes some of the oldest existing photographs of American lighthouses. They are reproduced here to convey a sense of what lighthouses were like either before the golden age began or as it emerged during the mid-1800s. Although a few date from the 1840s or early 1850s, most of these pictures were taken after 1852, when the Lighthouse Board began to make sweeping changes. Even so, they provide at least a glimpse of our nation's vanished "dawn lights."

RACE POINT LIGHTHOUSE (1840)

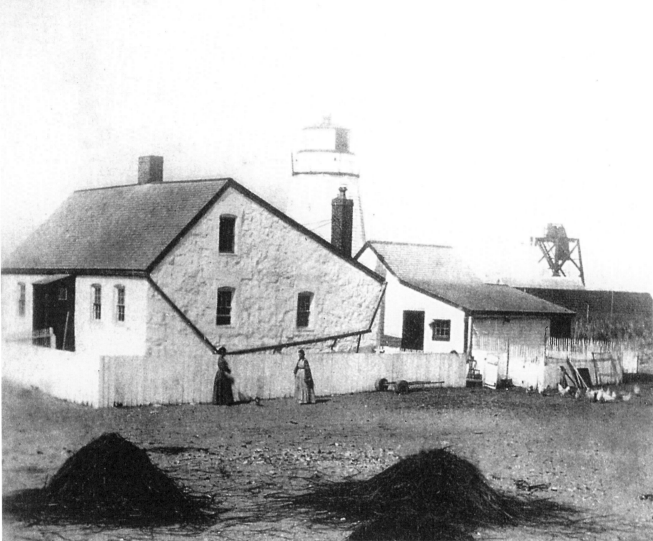

ONE OF THE OLDEST U.S. LIGHTHOUSE PHOTOS IN EXISTENCE, this image dates to approximately 1840, just a few years after the photographic process was invented. Built in 1816, the rustic stone tower and residence marked Race Point at the northern tip of Cape Cod. As the chickens and piles of hay suggest, the keepers who maintained this light also devoted time to farming. No doubt, like most early lighthouse keepers, they were expected to provide food for themselves and their families.

WEST CHOP LIGHTHOUSE (1818 TOWER)

A VINTAGE PHOTOGRAPH FEATURES A VERY EARLY VIEW of the West Chop Lighthouse, located near the entrance to Vineyard Haven Harbor on Martha's Vineyard. Established in 1818, the original station had a three-room house built of rubble and fieldstone and a 25-foot stone tower with an old-style birdcage lantern. Birdcage lanterns had many separate windowpanes and tended to diminish the brilliance and range of lighthouse beacons. Too small to accept the often sizable Fresnel lenses, most of these early lanterns were discarded by the Lighthouse Board during the last half of the nineteenth century.

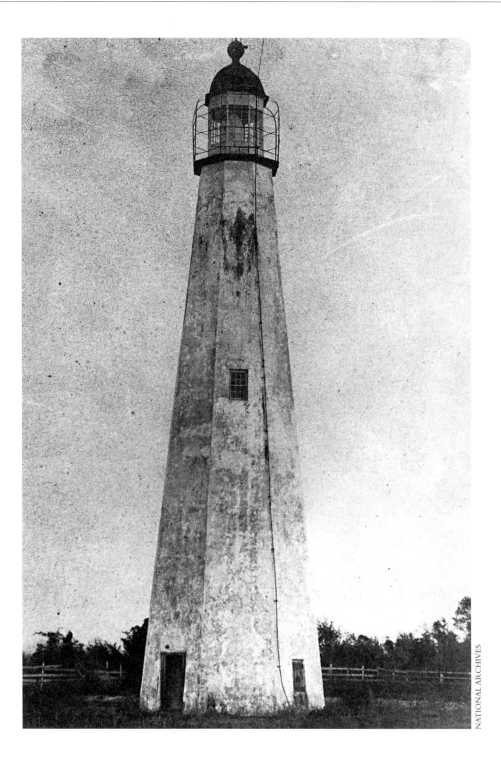

NATIONAL ARCHIVES

THIS PHOTOGRAPH OF GEORGIA'S ST. SIMONS ISLAND LIGHTHOUSE was taken before the Civil War. Built in 1801, the octagonal tower was blown up by Confederate troops as they retreated from the island in 1862.

PENSACOLA LIGHTHOUSE

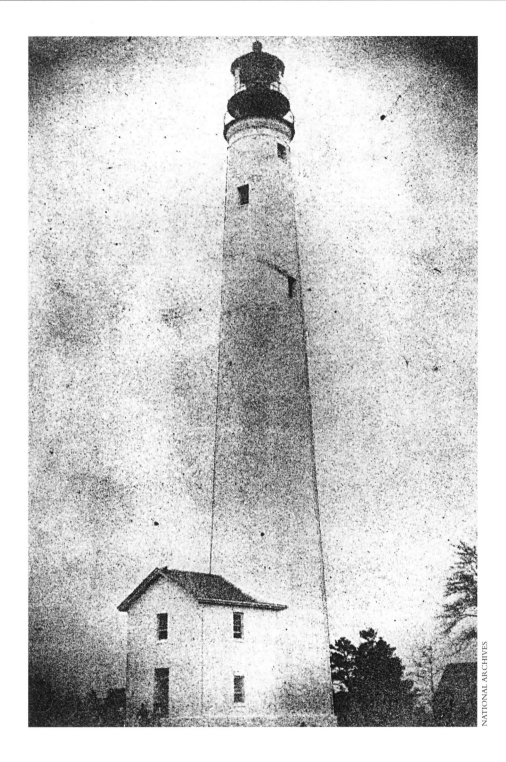

PENSACOLA, FLORIDA, HAS BEEN AN IMPORTANT U.S. NAVAL BASE for the better part of two centuries, and during the Civil War it played a vital role in securing the Gulf Coast for the Union. The Pensacola tower shown in this vintage photograph was built in 1859, only a couple of years before the war began. Its clean lines reflect the modernizing influence of the Lighthouse Board.

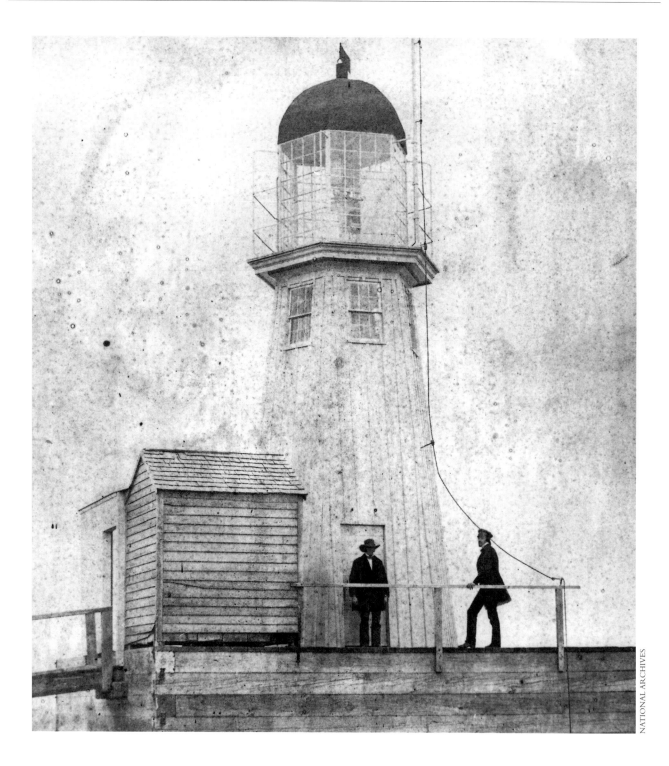

NATIONAL ARCHIVES

A VERY EARLY AND RARE IMAGE OF OHIO'S ASHTABULAH LIGHT on Lake Erie shows the station's octagonal tower on its wooden pier as well as the keeper and his assistant. Built in 1836, the original structure stood until 1876.

LONG ISLAND HEAD LIGHTHOUSE

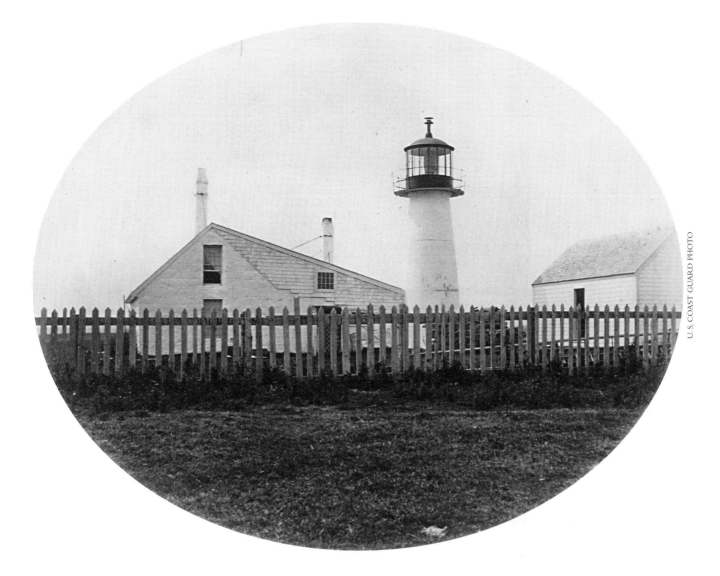

ALTHOUGH RARELY WILLING TO INVEST IN NEW TECHNOLOGIES, the Lighthouse Establishment administered by Stephen Pleasanton did experiment occasionally with new materials and concepts. For instance, America's first cast-iron light tower was erected at Long Island Head in inner Boston Harbor in 1844. Later on, the Lighthouse Board would make wide use of cast iron in tower construction.

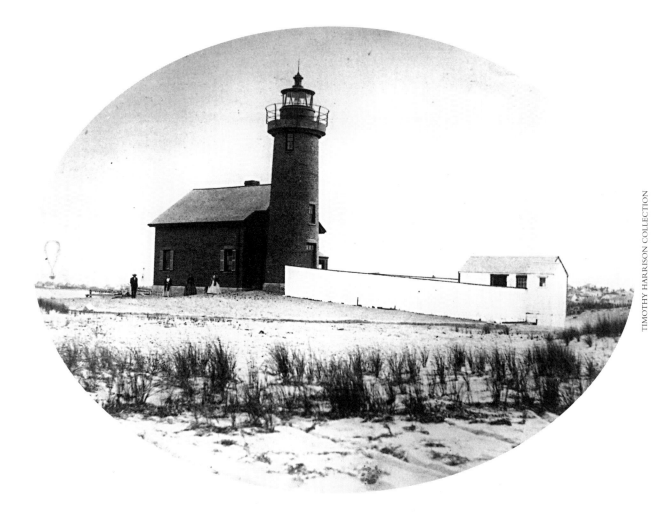

TIMOTHY HARRISON COLLECTION

THE CIVIL WAR STILL RAGED when this photograph of the Brant Point Lighthouse was taken in May 1864. The fighting never touched Brant Point, but the light station, established in 1746 to mark the entrance of Nantucket Harbor, was no stranger to violence and misfortune. Storms, fire, and decay had destroyed at least half a dozen earlier Nantucket lighthouses before this one was built in 1856. More durable than its predecessors, the brick tower remains standing nearly one and a half centuries after it was completed. However, it is no longer used as a lighthouse.

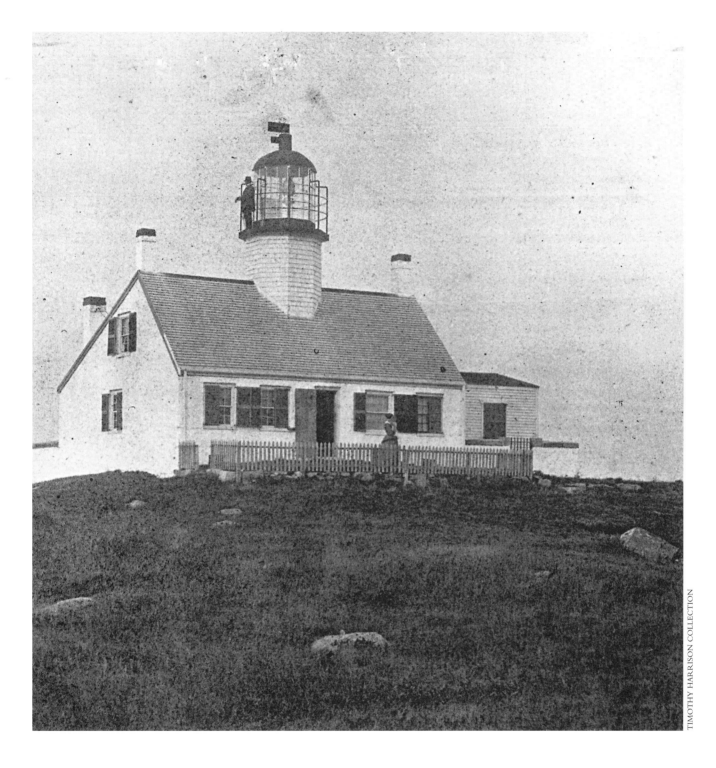

BUILT IN 1828, THE ORIGINAL NOBSKA LIGHTHOUSE near Woods Hole on Cape Cod consisted of a stone dwelling with an octagonal tower resting on its steep roof. The design proved an unfortunate one, especially for the keeper and his family, since the weight of the tower and lantern caused the roof to leak constantly.

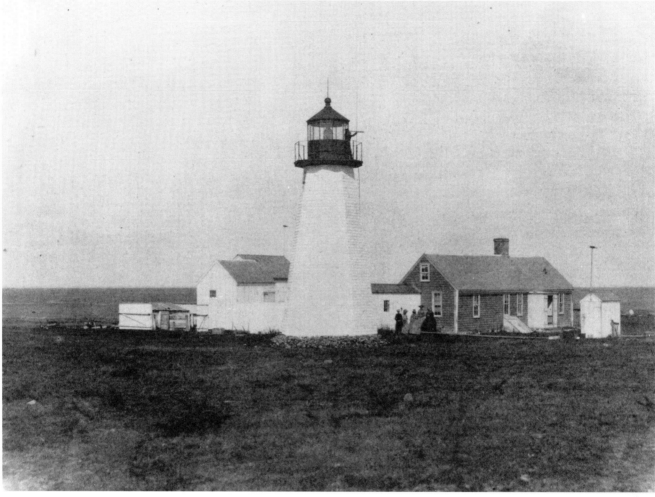

A MID-1800s VIEW OF THE CAPE POGE LIGHT STATION on Chappaquiddick Island near Edgartown, Massachusetts, features the keeper standing outside the lantern room blowing his fog trumpet. The keeper's family apparently turned out in their Sunday finest to have their picture taken. Unfortunately, the distant perspective makes it impossible to see the faces clearly. Built in 1844, the octagonal wooden tower was torn down in 1893.

POINT JUDITH LIGHTHOUSE

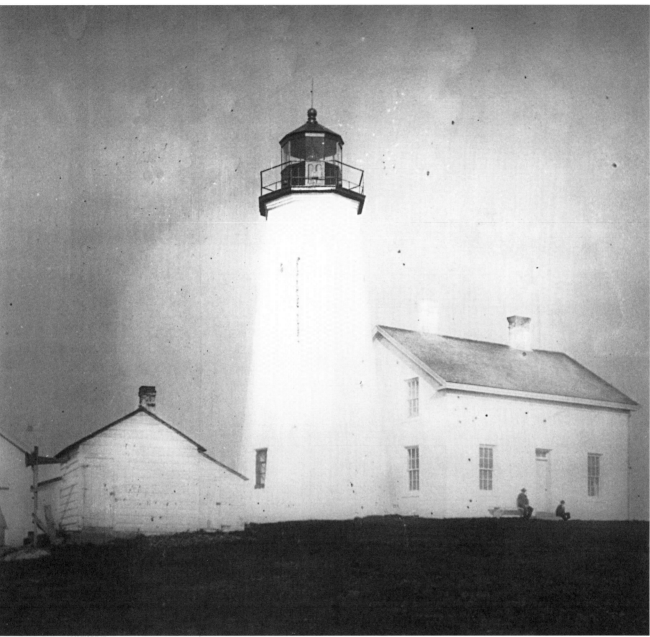

ESTABLISHED IN 1810, RHODE ISLAND'S POINT JUDITH LIGHTHOUSE has guided mariners through the turbulent waters near the junction of Narragansett Bay and Long Island Sound for more than 190 years. The Lighthouse Board updated the station in 1857, giving it a brownstone tower and a fourth-order Fresnel lens. This image likely dates to the 1860s or 1870s, when the tower walls were all white. Nowadays the upper half is painted brown.

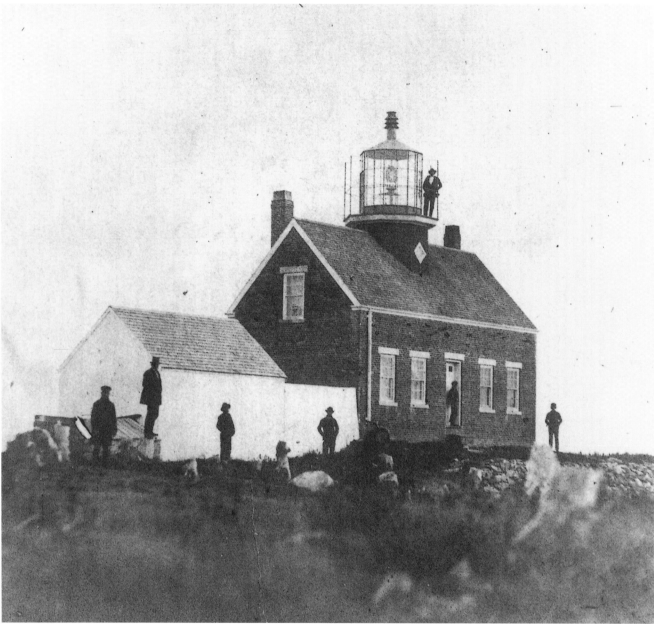

BUILT IN 1851, THE ORIGINAL GRINDLE POINT LIGHTHOUSE on Maine's Islesboro Island consisted of a modest keeper's dwelling with a lantern perched on its roof. The identity of the people in the picture is not known, but one of them was likely the keeper.

NATIONAL ARCHIVES

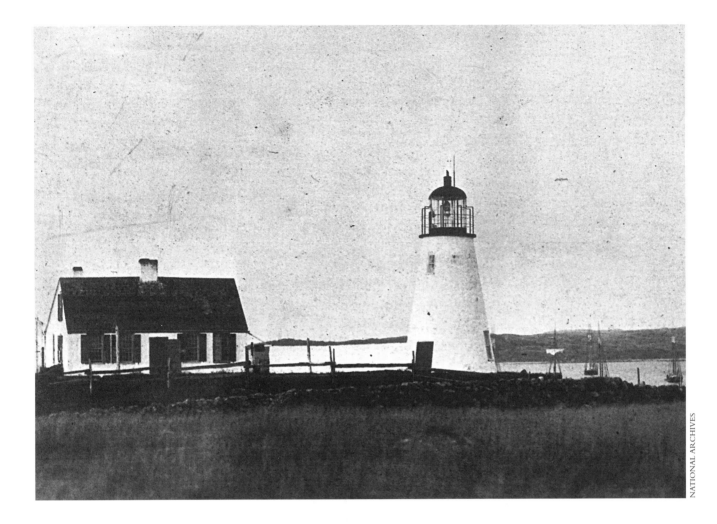

NATIONAL ARCHIVES

SCHOONERS ANCHOR JUST OFFSHORE in a nineteenth-century view of the Tarpaulin Cove Lighthouse near Gosnold, Massachusetts. This tower, built in 1818, no longer stands. It was replaced in the late 1800s by another structure.

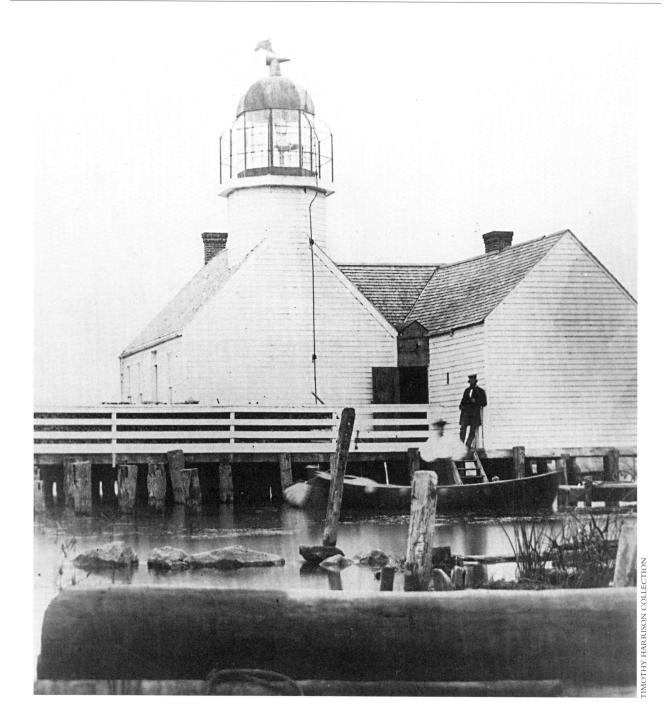

THIS EXTRAORDINARY MIDWESTERN LIGHTHOUSE marked Mama Juda Island, a marshy, low-lying thirty-acre tract located near the Canadian side of the Detroit River. The island was named for a Native American woman who operated a fishing camp here. Built in 1848, the structure had been torn down and replaced by 1866. The birdcage lantern appears to hold an old-style lamp-and-reflector system. The cable running down the wall grounds a lightning rod. Apparently, the keeper and his family made good use of the station boats.

TIMOTHY HARRISON COLLECTION

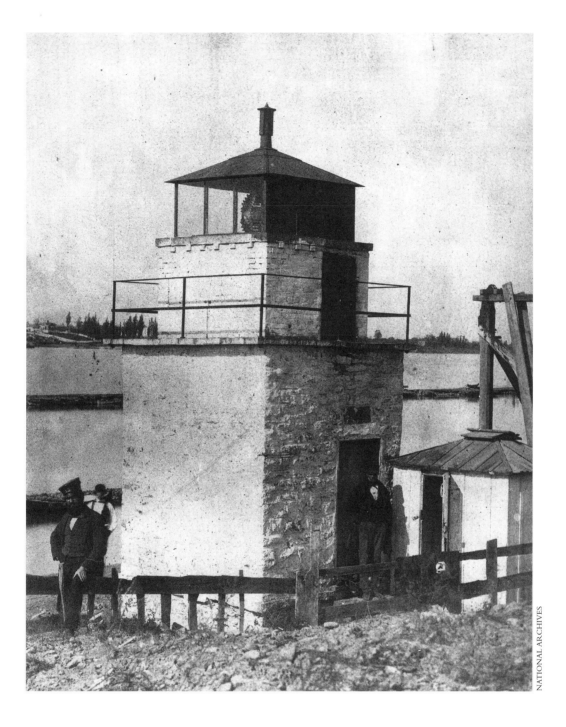

NATIONAL ARCHIVES

ALTHOUGH CRUDELY BUILT, THE BLACK ROCK FRONT RANGE LIGHT TOWER near Buffalo, New York, held a high-quality, fifth-order Fresnel lens. Functioning in tandem with a second light shining from a nearby rear range tower, the beacon marked the entrance to the Niagara River. Established in 1853, both lights were extinguished in 1870.

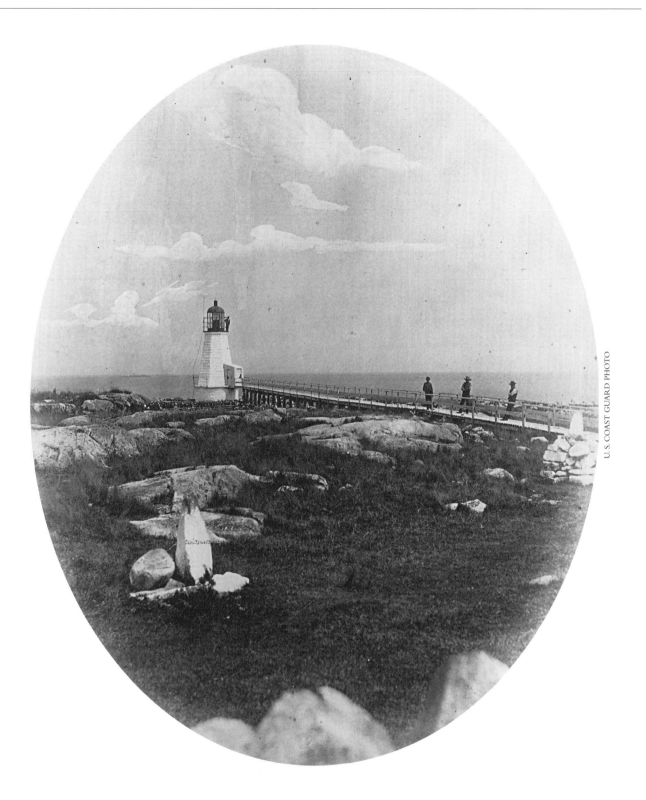

U.S. COAST GUARD PHOTO

NEW ENGLAND LITERARY LIGHTS Ralph Waldo Emerson and Henry David Thoreau often visited the seaside Massachusetts village of Rockport and likely enjoyed this view of the Straitsmouth Island Lighthouse. The photograph is a very early one, since the birdcage lantern shown here was replaced during the 1850s.

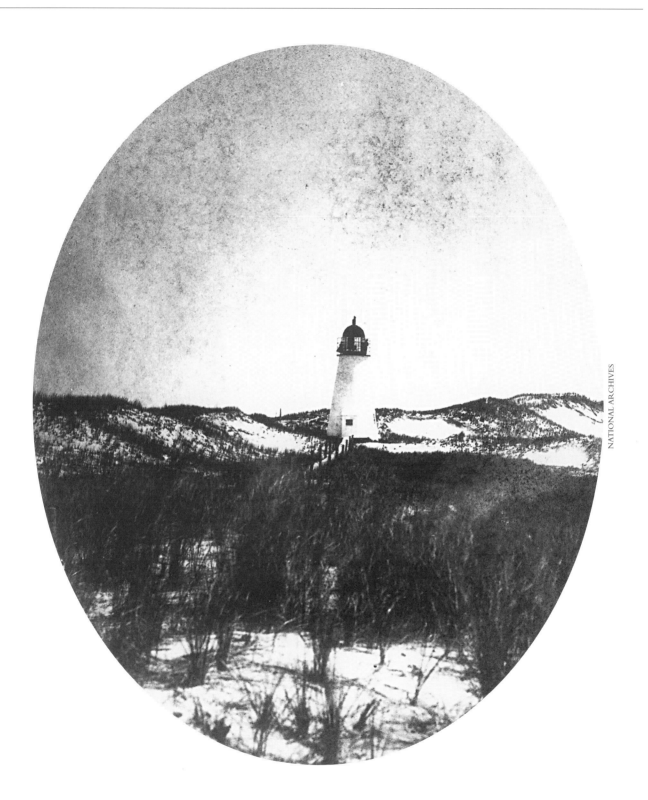

NATIONAL ARCHIVES

A FEW MILES WEST OF ROCKPORT, MASSACHUSETTS, a pair of range lights once guided vessels to the small port of Ipswich. The station's rear tower is shown rising from the sands near the entrance to the Ipswich harbor. In 1881 it was torn down and replaced by a cast-iron structure.

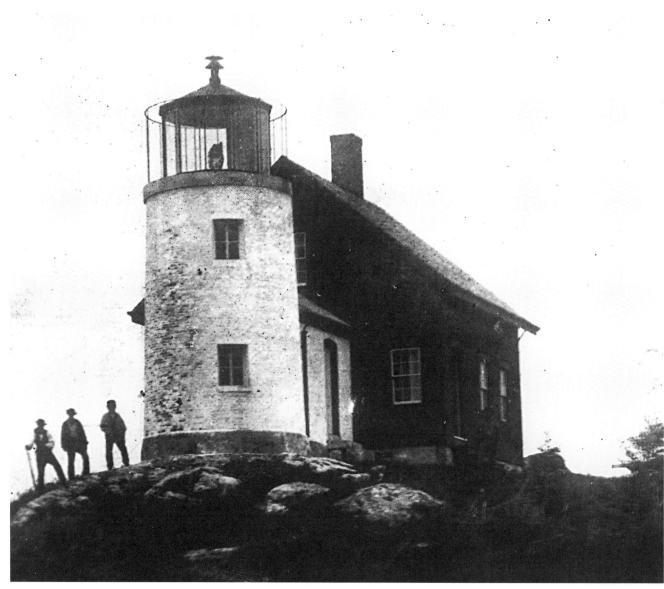

NATIONAL ARCHIVES

DESPITE EFFORTS BY THE LIGHTHOUSE BOARD to upgrade U.S. navigational aids, many remote light stations retained their rustic appearance for decades. This photograph of the Pumpkin Island Lighthouse near Little Deer Island, Maine, dates to 1890. Now privately owned, the old brick tower and wood-frame residence still stand.

THE LIGHTS GET BRIGHTER

Fresnel Lenses and Other Innovations

BY THE MIDDLE OF THE NINETEENTH CENTURY, the industrial revolution had begun to transform America. Once a land of pioneers and farmers, the United States was becoming a nation of engineers, entrepreneurs, factory workers, miners, and merchant seamen. As commerce grew, the volume of shipping along the East and West coasts and through the Great Lakes increased dramatically, and so, too, did the incidence of shipwreck.

In 1849 the brig *Saint John* foundered on Minot's Ledge off Cohasset, Massachusetts. Seeking shelter from a major storm, the brig's captain was unable to see a beacon at nearby Scituate that might have guided his vessel to safety. Instead of riding out the gale in the sheltered Scituate harbor, the *Saint John* struck the ledge and sank, carrying 143 hapless Irish immigrants to their deaths. This disaster was only one of many that occurred along poorly marked stretches of the U.S. coastline during the 1840s.

To help save ships and lives and cope with the burgeoning maritime traffic moving in and out of bustling American ports, the government sought to brighten the nation's shores. The system of navigational lights existing at the time the Lighthouse Board was founded in 1852 was clearly inadequate. To improve it, the government refurbished older light stations and built hundreds of new ones. Beacons and fog signals were updated and better maintained. Lighthouse depots were established to stockpile materials and repair equipment, and a fleet of tenders was launched to help supply remote light stations. Photographs in this chapter recall those efforts, which were to continue for nearly a century.

MINOT'S LEDGE LIGHTHOUSE

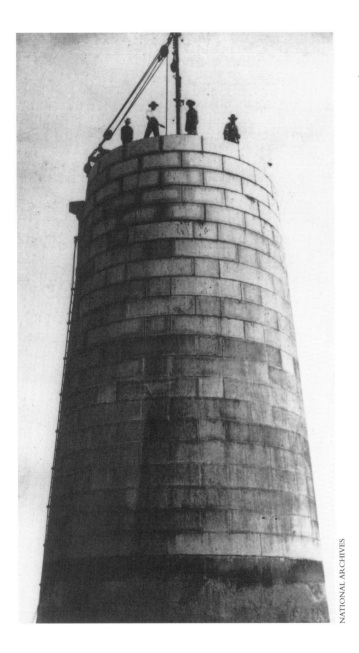

NATIONAL ARCHIVES

Winfield Scott Thompson, an early Minot's Ledge keeper.

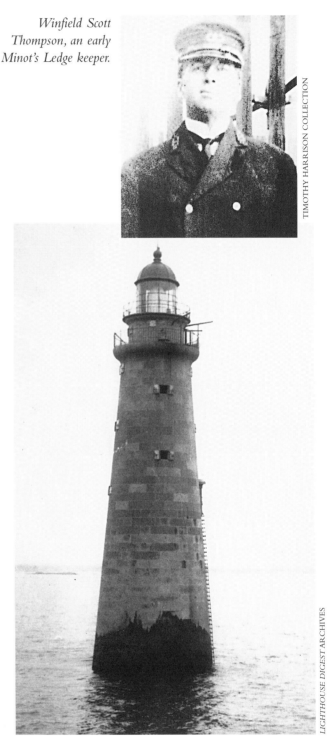

TIMOTHY HARRISON COLLECTION

LIGHTHOUSE DIGEST ARCHIVES

MANY OF THE TOWERS erected during the golden age were placed on exposed rocks, open water shoals, or wave-swept keys, where it was once thought impossible to build lighthouses. Shown under construction during the late 1850s, the Minot's Ledge Lighthouse stands on an offshore rock exposed only at low tide. Built with massive granite blocks, the hulking structure took the place of the experimental steel-skeleton tower that collapsed in 1851 (see page 6).

Above: The Minot's Ledge tower as it looks today. The tower's interlocking stones have enabled it to survive many storms, some even more powerful than the one that bowled over its predecessor.

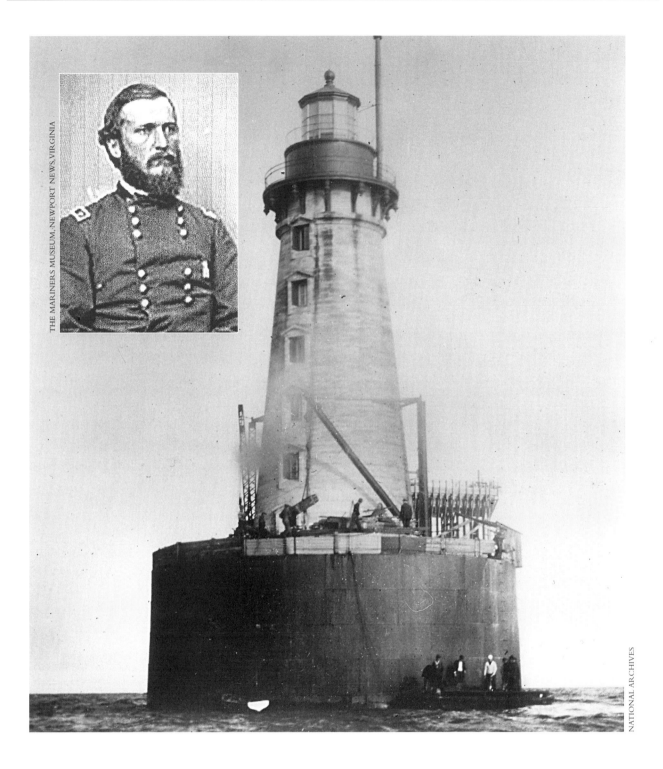

THE MARINERS MUSEUM, NEWPORT NEWS, VIRGINIA

NATIONAL ARCHIVES

STILL CONSIDERED A MAJOR ENGINEERING ACHIEVEMENT, the Stannard Rock Lighthouse was built over an open-water Lake Superior reef about 50 miles north of Marquette, Michigan. Completed in 1882, the station was designed by General Godfrey Weitzel (inset), who, like George Meade and William Rosecrans, fought for the Union during the Civil War.

LIGHT TOWERS, such as New York's West Bank Lighthouse (above) near Staten Island, were sometimes built on land, then moved by way of barge or freighter to their stations offshore. The photos on the facing page show the cast-iron tower under construction during the spring and summer of 1900, then after it was placed atop its steel and concrete caisson in 1901. The sturdy structure stills stands and serves mariners as an active aid to navigation.

West Bank keeper and assistants (names unknown).

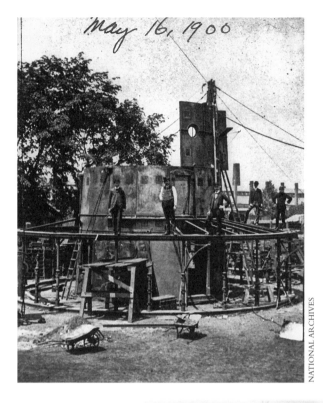

May 16, 1900

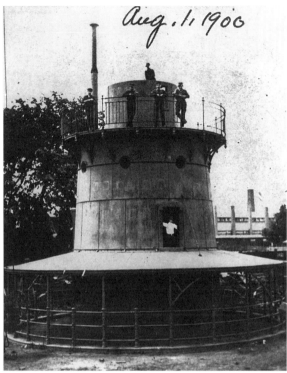

Aug. 1, 1900

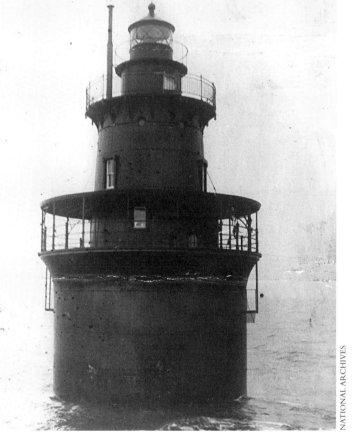

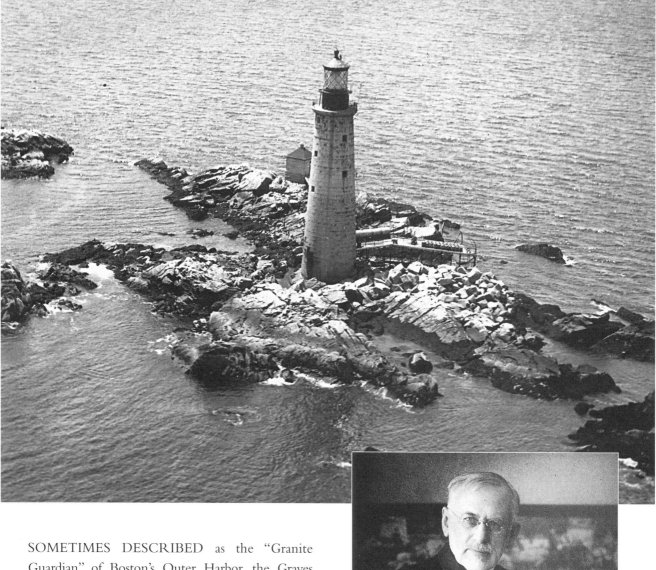

SOMETIMES DESCRIBED as the "Granite Guardian" of Boston's Outer Harbor, the Graves Lighthouse has guided mariners for nearly a century. Considered a marvel of American engineering, the 113-foot tower took nearly two years to build. Its heavy granite blocks were cut on nearby Cape Ann and transported to the construction site on a schooner. Built under the supervision of Colonel William Stanton (right), a U.S. Army engineer, the station was ready for service in 1905.

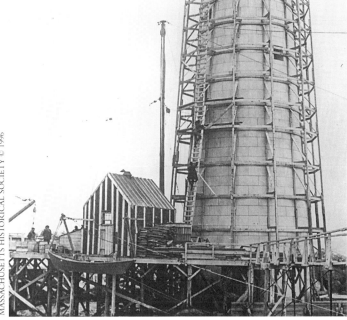

The photos above and below show the Graves Lighthouse under construction. The blueprint (right) shows the outside of the tower and an inside view of five lower rooms, cistern, lantern, and Fresnel lens.

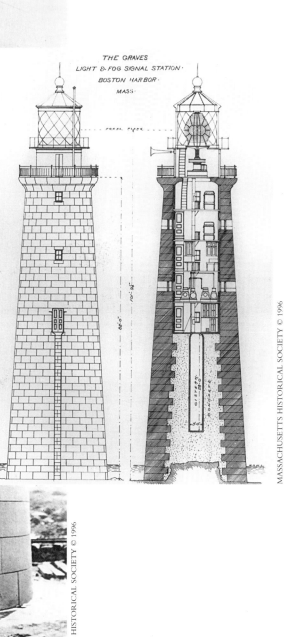

THE GRAVES
LIGHT & FOG SIGNAL STATION·
BOSTON HARBOR·
MASS·

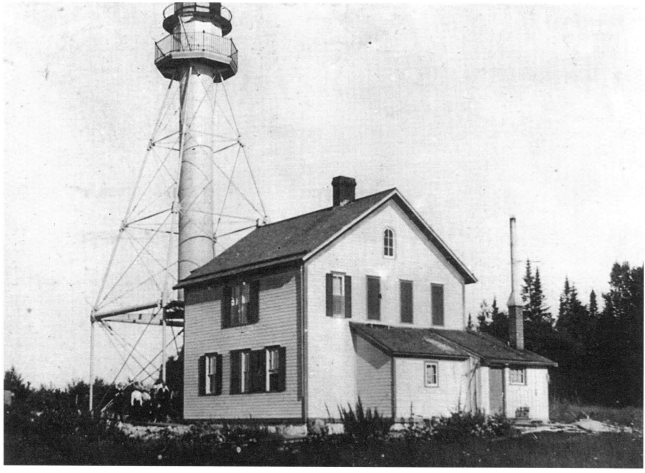

COURTESY GEORGE LEONARD

BUILDING LIGHTHOUSES in remote offshore locations remained a considerable challenge for engineers and construction crews well into the twentieth century. Originally, Lake Huron's dangerous Detour Reef southeast of Sault Ste. Marie was marked by a light station (above) on the Michigan mainland. Its beacon was never considered entirely adequate, however, and during the 1930s, government crews tackled the difficult task of building a lighthouse in open water directly over the reef. Taken in 1931, the photographs on the facing page show three stages of the construction process: building the station's massive concrete platform (left), raising the tower itself (right), and the as yet unfinished lighthouse with lantern in place (bottom center).

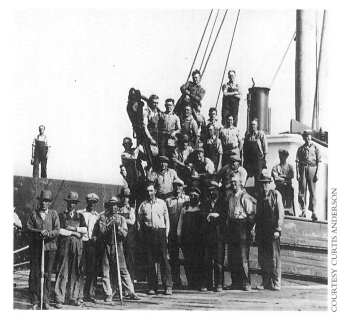

COURTESY CURTIS ANDERSON

The crew that built the offshore lighthouse.

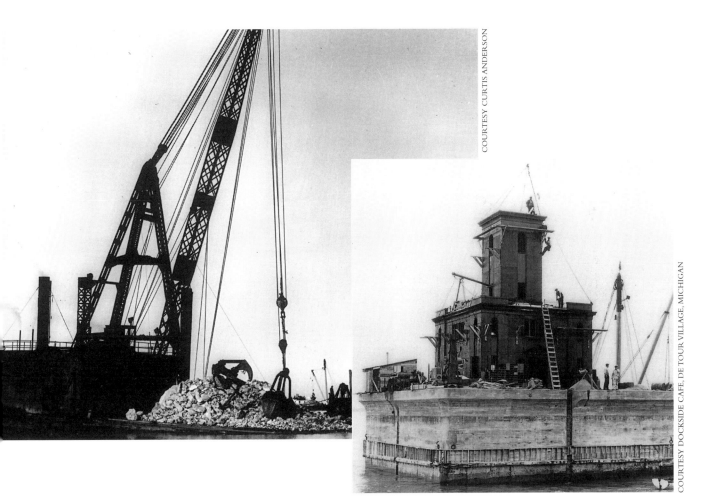

COURTESY CURTIS ANDERSON

COURTESY DOCKSIDE CAFE, DE TOUR VILLAGE, MICHIGAN

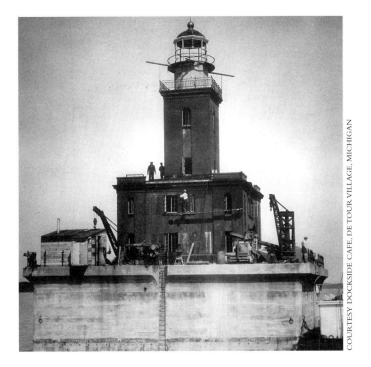

COURTESY DOCKSIDE CAFE, DE TOUR VILLAGE, MICHIGAN

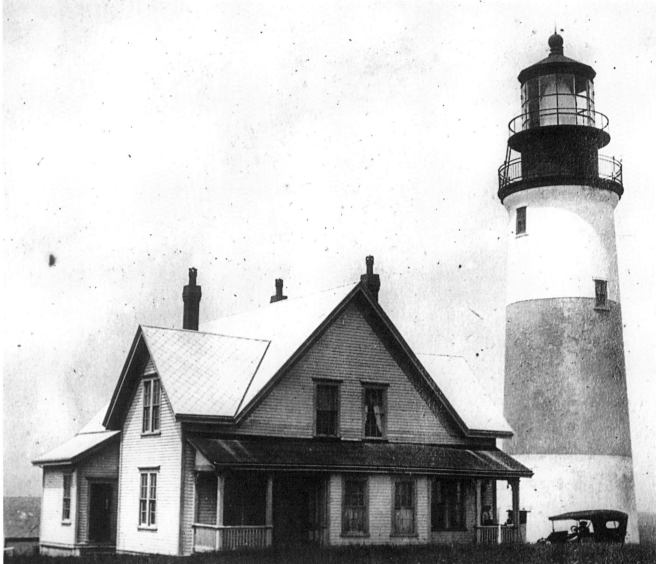

U.S. COAST GUARD PHOTO

THE GOVERNMENT IMPROVED AMERICA'S SYSTEM OF NAVIGATIONAL MARKERS not just by building better lighthouses in more appropriate locations, but also by providing them with more sophisticated optics and fog signals. The French-designed and manufactured Fresnel lens represented the best available optical technology. The Sankaty Light Station's sparkling second-order lens remained in place when this early-twentieth-century photograph was taken. After the station was automated in 1965, the huge lens was removed in favor of a so-called modern optic.

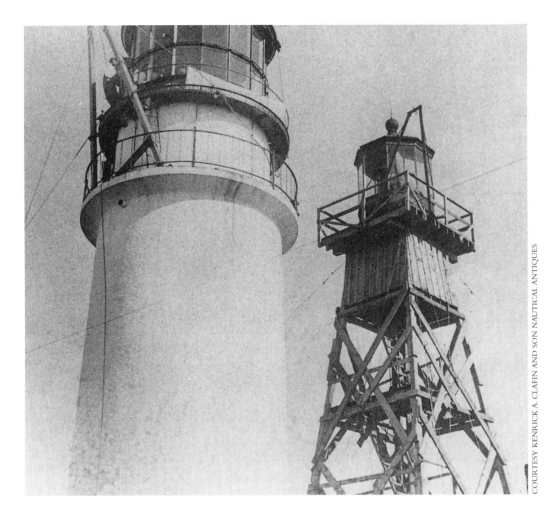

COURTESY KENRICK A. CLAFIN AND SON NAUTICAL ANTIQUES

FRESNEL LENSES were often quite large and heavy. Many lighthouse towers had to be altered so the big lenses would fit inside their lantern rooms. When the Cape Cod Lighthouse received its enormous first-order lens in 1901, the tower had to be substantially modified. A temporary wooden tower served the station while the work was being done.

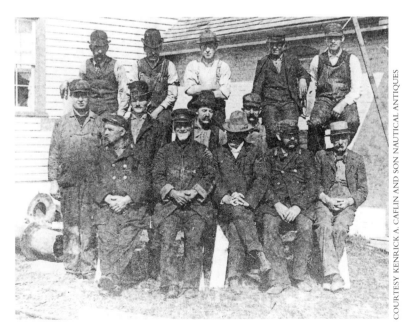

COURTESY KENRICK A. CAFLIN AND SON NAUTICAL ANTIQUES

The work crew that built the temporary tower and refitted the old one.

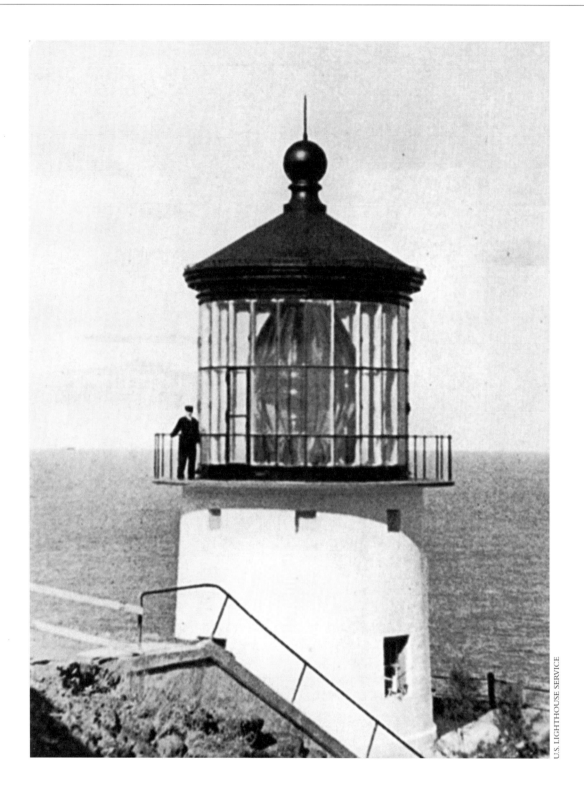

U.S. LIGHTHOUSE SERVICE

THE LARGEST OPTICAL DEVICE ever installed in an American lighthouse is the 9-foot-wide Fresnel lens at the Makapuu Point Light Station on Oahu, Hawaii. This photograph depicts a 1936 view of the Makapuu tower and its enormous lens.

POINT WILSON LANTERN AND COMPRESSOR

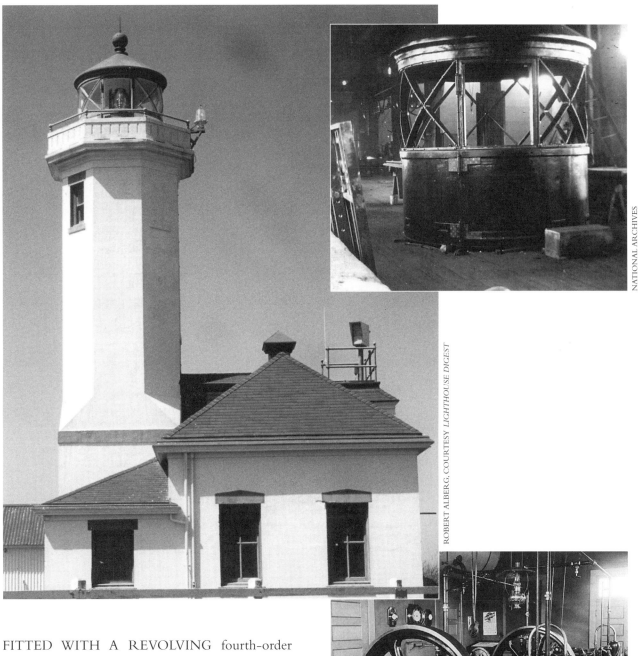

NATIONAL ARCHIVES

ROBERT ALBERG, COURTESY *LIGHTHOUSE DIGEST*

NATIONAL ARCHIVES

FITTED WITH A REVOLVING fourth-order Fresnel lens in 1894, the Point Wilson Lighthouse on Admiralty Inlet in Washington State needed a larger lantern, shown here under construction in a metal shop. That same year, the station was equipped with a new boiler and fog signal compressors (right).

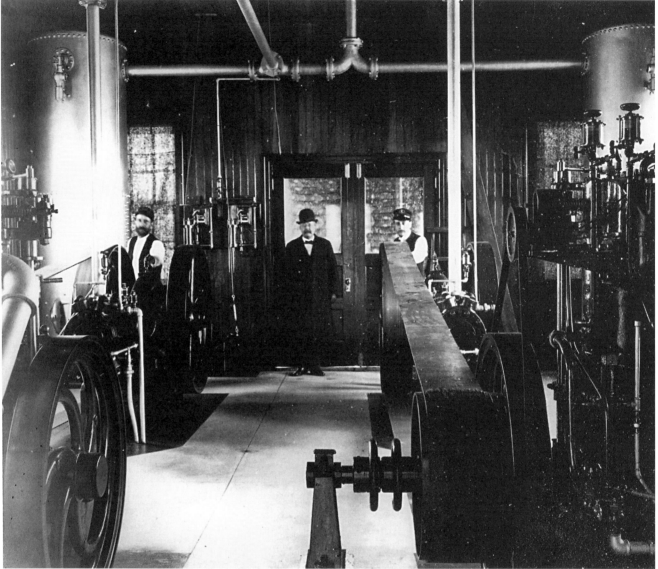

NATIONAL ARCHIVES

THE BOILERS, BELTS, AND FLYWHEELS inside California's Carquinez Strait whistle house could be mistaken for factory equipment, but the product they manufactured was a shrill signal intended to warn mariners in foggy weather. The station's keeper is on the right and his assistant on the far left. The dapper gentleman by the door is likely a lighthouse inspector.

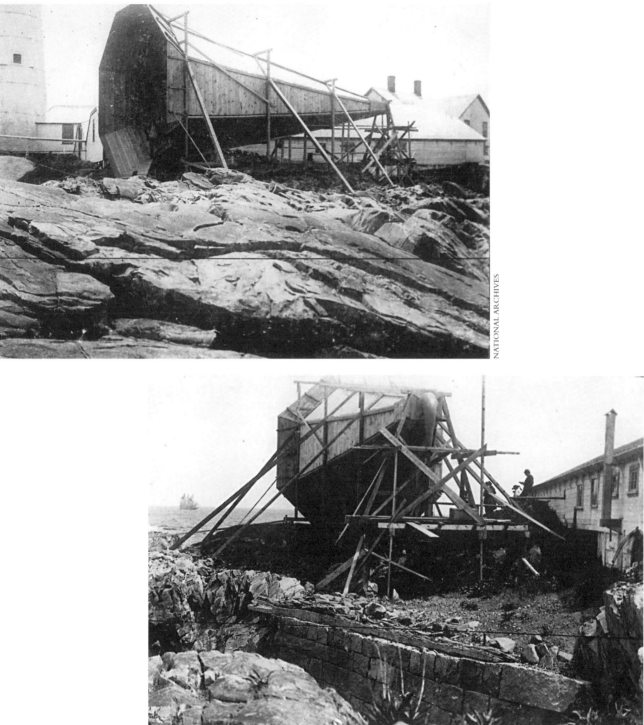

EFFORTS TO WARN MARINERS with sound signals could reach extremes, as with this amplifier horn that once served the Boston Harbor Light Station. The horn was built in an attempt to fill a so-called silent spot several miles offshore.

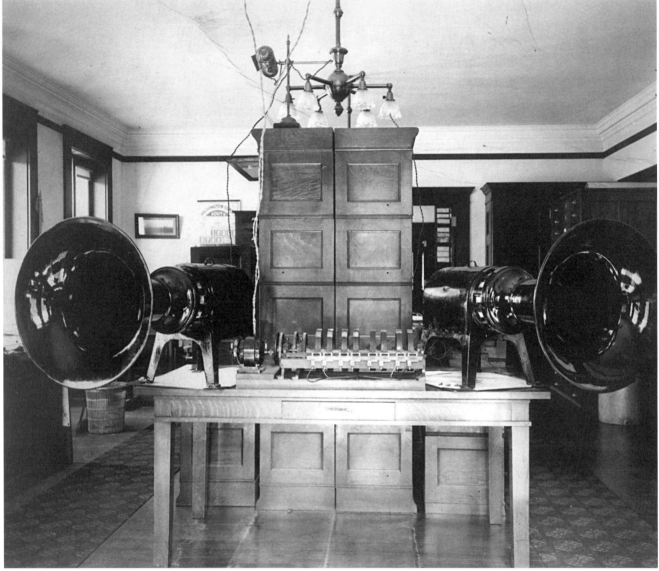

THIS RATHER AMAZING double-horn fog signal device saw use at the Alcatraz Island Lighthouse just inside the Golden Gate in San Francisco Bay.

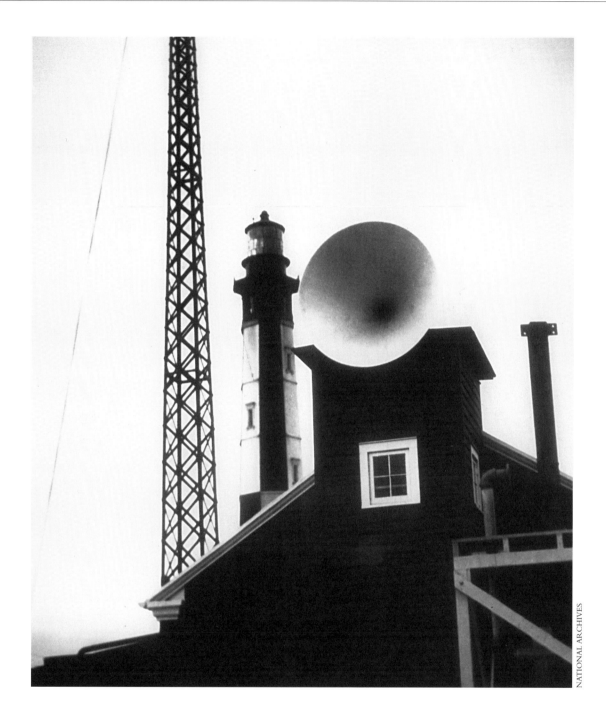

NATIONAL ARCHIVES

THIS EARLY- TO MID-TWENTIETH-CENTURY VIEW of the Cape Henry Lighthouse, near the entrance to Chesapeake Bay in Virginia, demonstrates the variety of means—sometimes experimental—used to guide mariners. The fog signal building has been fitted with an unusual horn. Behind it is the light tower and a radio transmission tower. Early radio beacons, such as the one at Cape Henry, helped mariners far out at sea find their positions. These invisible beacons, however, were of little use to vessels running close to shore.

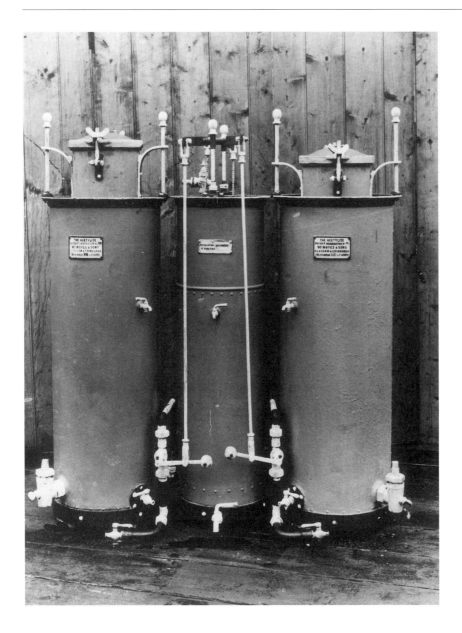

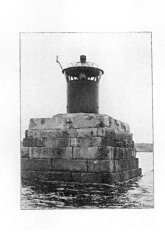

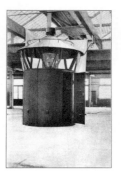

THE INTRODUCTION OF COMPRESSED ACETYLENE as a lamp fuel made it possible to automate light signals. Towers and buoys fitted with acetylene lamps required only occasional visits by Lighthouse Service personnel to refuel or repair them. The acetylene tanks above left served the Turn Point Light Station in Washington's San Juan Islands. Acetylene buoy lights and other automated light signals like those shown here could be counted on to shine for weeks at a time without attention from keepers. The images on the top right of this page and on the facing page are from an antique sales and promotional brochure of the American Gasaccumulator Company, which sold acetylene lamps.

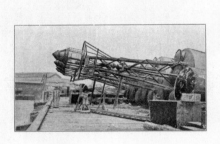

AMERICAN GASACCUMULATOR CO.
PHILADELPHIA, PA., U. S. A.

THE AGA LIGHT-AND WHISTLE BUOY BW-600 I
AS DELIVERED TO U. S. LIGHT-HOUSE BOARD.

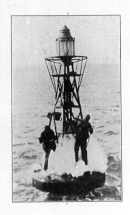

AMERICAN GASACCUMULATOR CO.
PHILADELPHIA, PA., U. S. A.

BW-600 II BUOY IN AMBROSE CHANNEL, NEW YOR
BEING FREED FROM ICE.

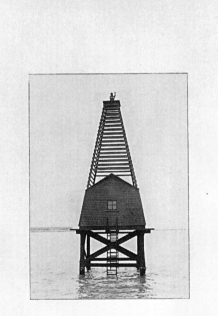

AMERICAN GASACCUMULATOR CO.
PHILADELPHIA, PA., U. S. A.

REAR RANGE
PORT BOLIVAR, TEXAS.

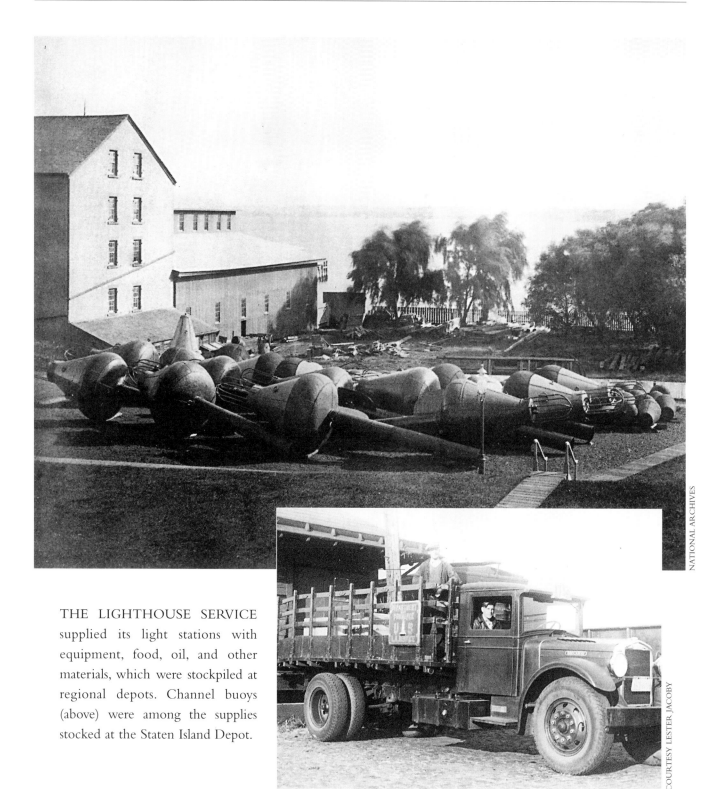

THE LIGHTHOUSE SERVICE supplied its light stations with equipment, food, oil, and other materials, which were stockpiled at regional depots. Channel buoys (above) were among the supplies stocked at the Staten Island Depot.

A truck is loaded with supplies likely destined for a nearby light station. The man in the cab is Lester Jacoby, who spent thirty-seven years in the Lighthouse Service and the Coast Guard. The photo dates to the early 1930s.

This pile of lumber in front of the Detroit Depot may have been used to build a new home for some Great Lakes keeper and his family.

Fuel for oil lamps rolls out of storage at the depot in Ketchikan, Alaska.

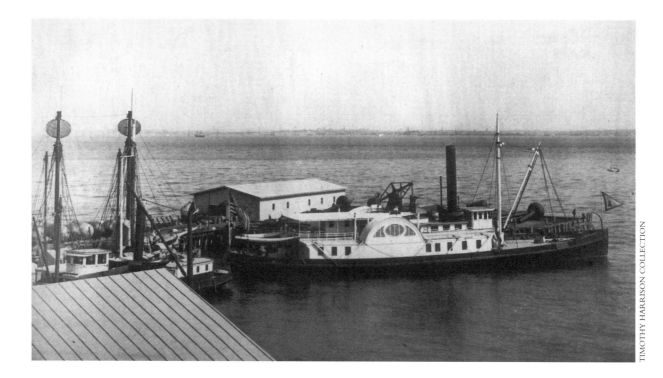

USUALLY LIGHT STATION SUPPLIES were delivered by tenders like this side-wheeler at the Staten Island Depot. A pair of lightships are moored on the left.

The lighthouse tender Azalea.

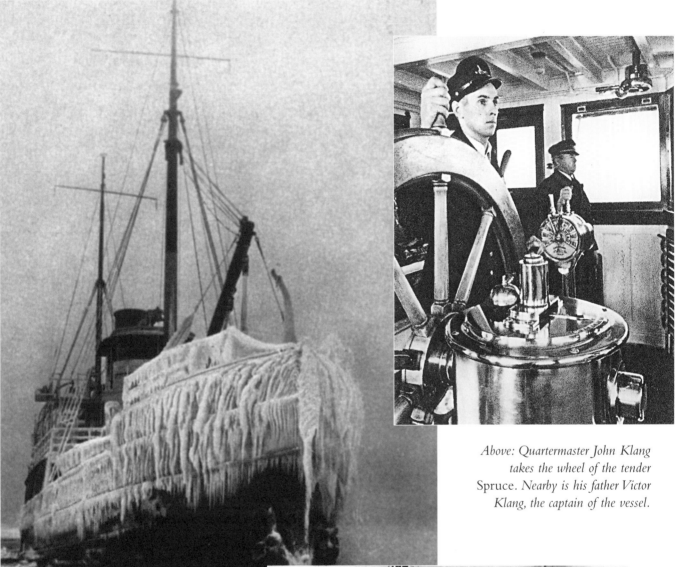

U. S. LIGHTHOUSE SERVICE

TIMOTHY HARRISON COLLECTION

Above: Quartermaster John Klang takes the wheel of the tender Spruce. *Nearby is his father Victor Klang, the captain of the vessel.*

Above: A particularly severe Great Lakes winter has trapped the tender Marigold *in ice.*

The tender Amaranth.

TIMOTHY HARRISON COLLECTION

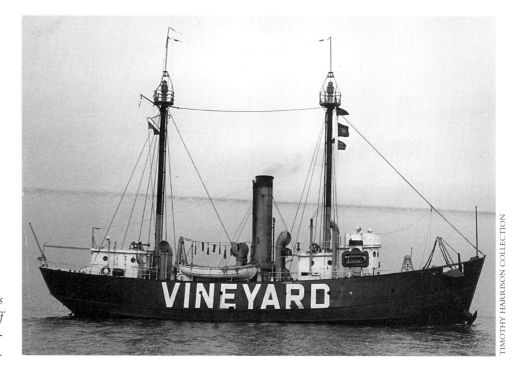

TIMOTHY HARRISON COLLECTION

The Vineyard *guided vessels through treacherous waters off Cape Cod, as did the diminutive* Handkerchief *(below).*

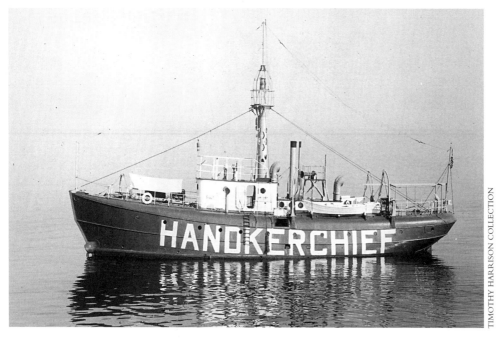

TIMOTHY HARRISON COLLECTION

THE LIGHTHOUSE SERVICE used lightships to identify shipping lanes or mark remote navigational obstacles where it was impossible or too costly to build a lighthouse. These small vessels, often of no more than a few hundred tons, were in essence floating lighthouses. Their beacons were displayed from one or more masts. Lightships were vulnerable to collisions and storms and were considered to be among the most dangerous duty stations for keepers.

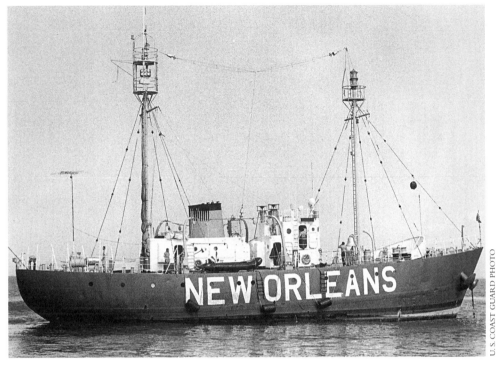

The lightship New Orleans *marked the mouth of the Mississippi River.*

U. S. COAST GUARD PHOTO

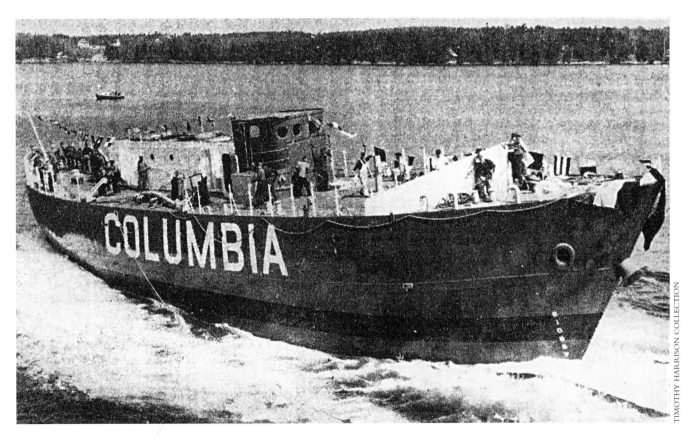

Shown here being launched in April 1920, the lightship Columbia *marked the mouth of the Columbia River.*

TIMOTHY HARRISON COLLECTION

CAREER KEEPERS AND THEIR FAMILIES

The Hard-working Men and Women Who Kept the Lights Burning

SINCE 1716, when America's first light station was established to mark the entrance to Boston Harbor, thousands of hard-working men and women have dedicated themselves to guiding ships and safeguarding those on board. Many spent their entire lives keeping navigational lights. In fact, some families can open photograph albums and point to several generations of lighthouse keepers.

During the golden age—roughly 1852 to 1939—nearly all American keepers worked for the U.S. Lighthouse Service. After 1939, most were either members of the U.S. Coast Guard or civilians employed by the Coast Guard. But regardless of the uniforms they wore, keepers thought of themselves as professional lighthouse men or women. They called themselves "wickies," a humorous term derived from the constant need to the trim the wicks of oil or kerosene lamps in old-time lighthouses, and considered themselves a breed apart. Indeed, theirs was an occupation that demanded qualities not found in most people—for instance, hardiness in all weathers, a willingness to work at night, and above all, a tolerance for loneliness.

Although a few lighthouses were in coastal towns, many were located on rugged headlands or barren ledges far from the nearest village. Some keepers had only seals and seabirds for neighbors. When gales struck, keepers had to stay at their posts and take whatever the ocean threw at them. Unlike the mariners they served, they could not outrun the storm or escape to some sheltered harbor. No matter what the conditions, their lights had to shine all night and every night since ships, property, and—most important—lives depended on them.

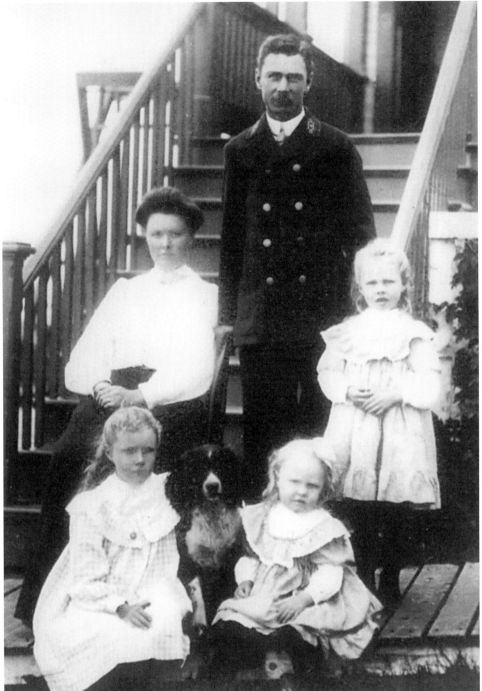

Lighthouse keepers have become the stuff of legend. We think of them as heroes who loved the sea, the wind, the cold, and even the isolation. Many were heroes and proved it, but most were ordinary people who performed their duties as best they could in return for a modest salary—often no more than a few hundred dollars a year—and a place to live. On the following pages we'll meet some of the men and women who kept America's coastal lights burning.

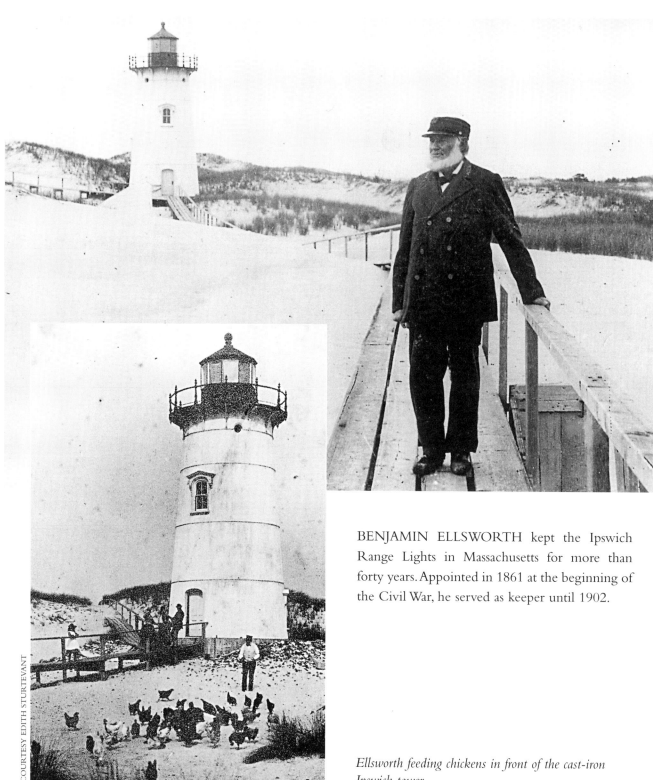

BENJAMIN ELLSWORTH kept the Ipswich Range Lights in Massachusetts for more than forty years. Appointed in 1861 at the beginning of the Civil War, he served as keeper until 1902.

Ellsworth feeding chickens in front of the cast-iron Ipswich tower.

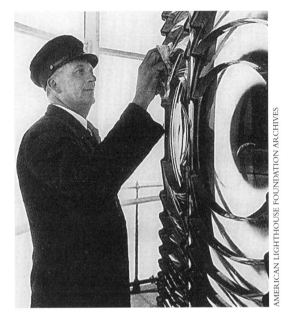

ESTABLISHED IN 1803, the Cape Hatteras Light Station in North Carolina had a substantial list of keepers. Among those who served longest was Unaka Jennette, shown polishing the station's room-size first-order Fresnel lens in this 1933 photograph.

John Bunyan Quidley, an assistant keeper who served at Cape Hatteras and other North Carolina lighthouses during the early twentieth century.

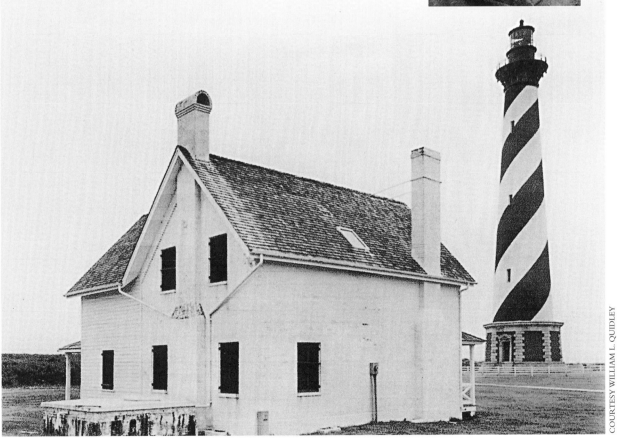

The Cape Hatteras Light Station about a century ago.

GEORGE LYON AND EGG ROCK

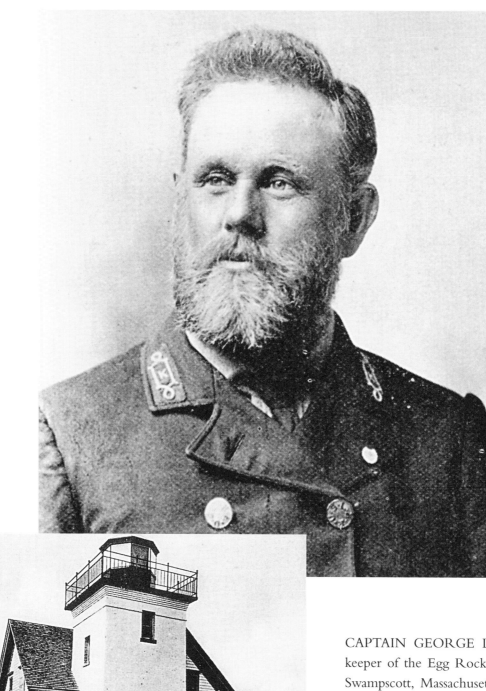

LIGHTKEEPER MAGAZINE/TIMOTHY HARRISON COLLECTION

LIGHTHOUSE DIGEST ARCHIVES

CAPTAIN GEORGE LYON became keeper of the Egg Rock Lighthouse at Swampscott, Massachusetts, in 1889. A visitor described Lyon as "bronzed and blue-shirted, his yellow beard suggesting a Norseman of old, and his welcome seconded by his mother, a woman of almost ninety years of age." Lyon later became keeper of the Graves Lighthouse in Boston Harbor.

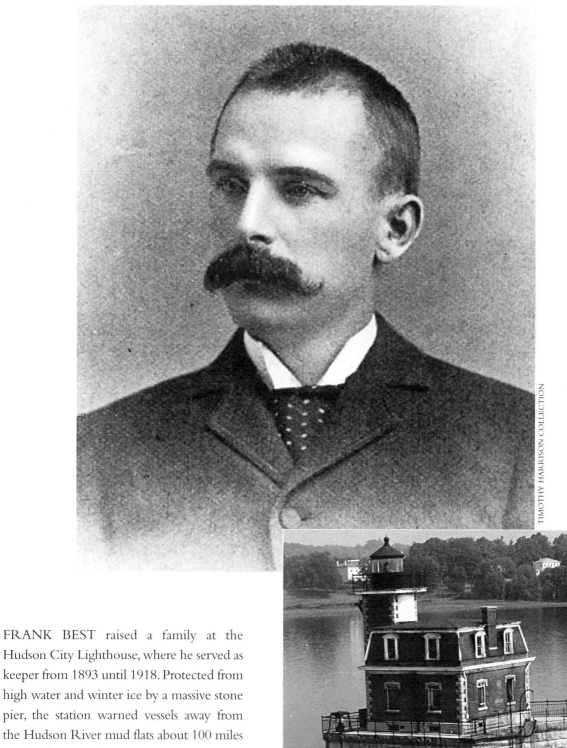

TIMOTHY HARRISON COLLECTION

U. S. COAST GUARD PHOTO

FRANK BEST raised a family at the Hudson City Lighthouse, where he served as keeper from 1893 until 1918. Protected from high water and winter ice by a massive stone pier, the station warned vessels away from the Hudson River mud flats about 100 miles north of New York City.

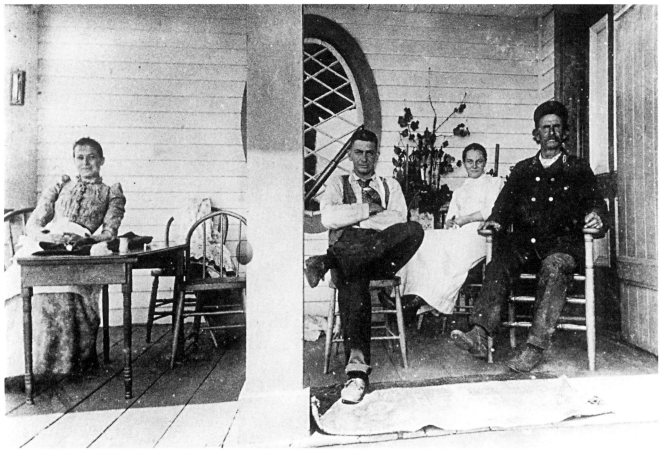

COURTESY MARGARET BUCKRIDGE

AS AN ADVENTUROUS young sailor, John Buckridge accompanied Commodore Matthew Perry on his 1853 expedition to Japan and is said to have been one of the first westerners to spend a night on Japanese soil. Shown above is Buckridge and his family at the Lynde Point Lighthouse in Old Saybrook, Connecticut, where he served as keeper from 1883 to 1902.

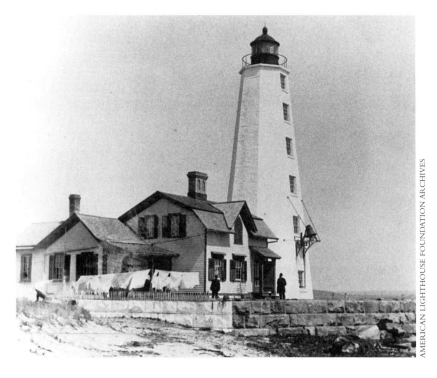

The lighthouse as it appeared in 1885, not long after Buckridge became its keeper.

AMERICAN LIGHTHOUSE FOUNDATION ARCHIVES

LIGHTHOUSE DIGEST ARCHIVES

CAREER KEEPER GEORGE BURZLAFF served at several different Great Lakes light stations, including Point Iroquois and Grassy Island on the Detroit River. Burzlaff began working for the U.S. Lighthouse Service in 1907 at an annual salary of $425, or $8.17 a week. By 1939, when the Coast Guard took over the Lighthouse Service, Burzlaff was earning $30 a week. He retired in 1946 after more than thirty-eight years of keeping Midwestern lighthouses.

NATIONAL ARCHIVES

One of the Grassy Island, Michigan, range lights.

COURTESY BACON MEMORIAL LIBRARY

Grassy Island Lighthouse where George Burzlaff once lived.

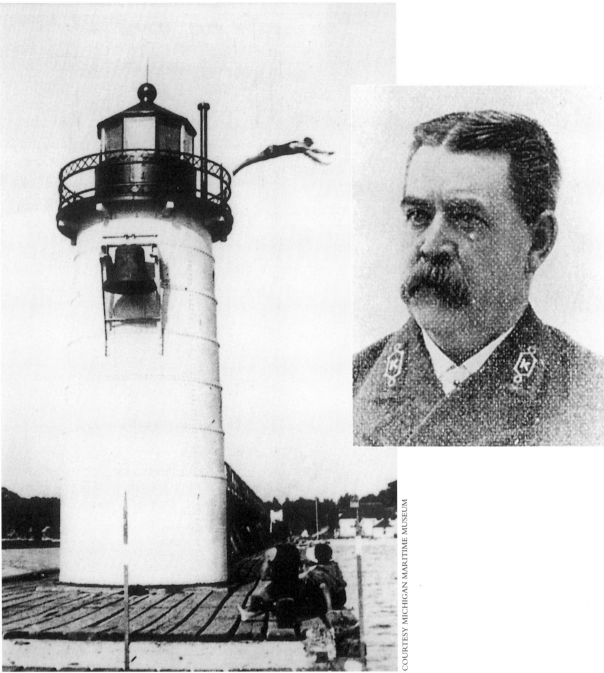

COURTESY MICHIGAN MARITIME MUSEUM

COURTESY MICHIGAN MARITIME MUSEUM

A CIVIL WAR HERO, Captain James Donahue was appointed keeper of Michigan's South Haven Lighthouse in 1874. He held the same job for thirty-five years, finally retiring from the Lighthouse Service in 1909. Having lost a leg at the Battle of the Wilderness in 1864, Donahue never enjoyed a dive from the tower like the exuberant youth in the 1920s photograph above left.

FREDERIC MORONG JR.

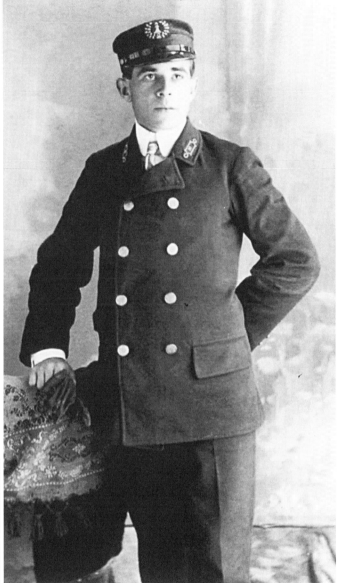

FREDERIC MORONG JR. knew all about the hard, monotonous work of maintaining a lighthouse. The son of a keeper who served at several Maine light stations, Morong worked for many years as a Lighthouse Service machinist during the early twentieth century. No doubt, he was all too familiar with the tedious chore of keeping light station brasswork bright and shiny. As handy with words as he was with machinery, Morong wrote a poem on the subject:

It's BRASSWORK
Oh what is the bane of a lighthouse keeper's life,
That causes him worry, struggle and strife,
That makes him use cuss words and beat on his wife?

It's BRASSWORK. . . .
The devil himself could never invent,
A material causing more worldwide lament,
And in Uncle Sam's service about ninety percent

Is BRASSWORK. . . .
The machinery, clockwork, and fog signal bell,
The coal hods, the dustpans, the pump in the well,
No, I'll leave it to you mates if it isn't, well

BRASSWORK
I dig, scrub and polish, and work with a might,
And just when I get it all shining bright,
In comes the fog like a thief in the night,

Goodbye BRASSWORK. . . .
Oh, why should the spirit of mortal be proud,
In the short span of life that he is allowed,
If all the lining in every dark cloud

Is BRASSWORK
And when I have polished until I am cold,
And I have taken my oath to the heavenly fold,
Will my harp and my crown be made of pure gold?

No! BRASSWORK

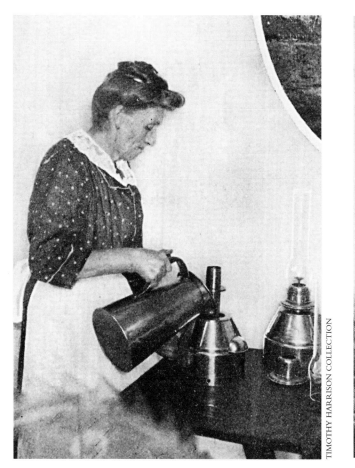

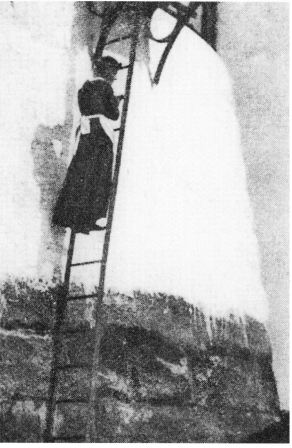

THE HARD WORK of keeping a lighthouse could be—and often was—done by women. Appointed to replace her husband after he died of pneumonia in 1886, Kate Walker kept New York's Robbins Reef Light for thirty-four years. Walker is shown above refilling oil lamps and climbing down the station ladder.

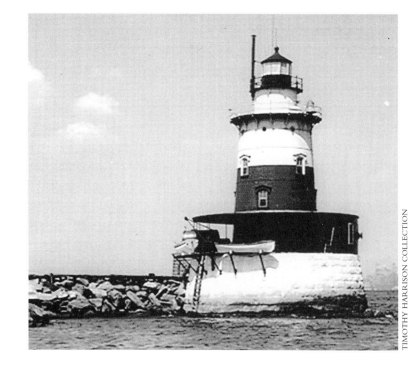

TIMOTHY HARRISON COLLECTION

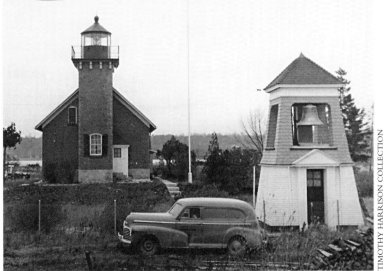

TIMOTHY HARRISON COLLECTION

MORE THAN A FEW WOMEN had lengthy careers as lighthouse keepers. Elizabeth Williams kept the Little Traverse Light on Lake Michigan from 1884 until 1913, a span of twenty-nine years. Earlier she had served for a dozen years as keeper of a lighthouse on Beaver Island.

DURING THE 1930s AND 1940s, Fannie Salter kept the Turkey Point Light on the western shore of Chesapeake Bay in Maryland.

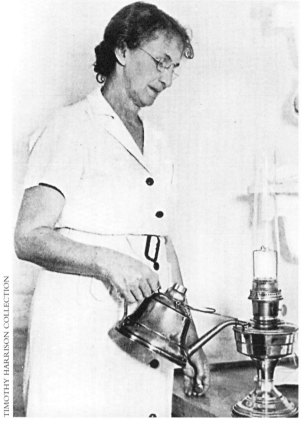

Above and right: Salter filling an oil lamp and polishing the Fresnel lens.

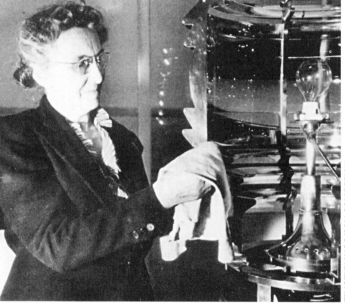

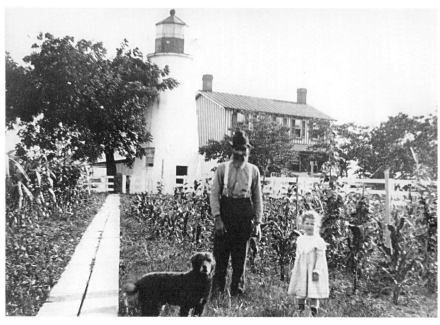

The figures in this vintage photograph of the Turkey Point Station are not identified, but perhaps the fisherman and young girl are Salter's relatives.

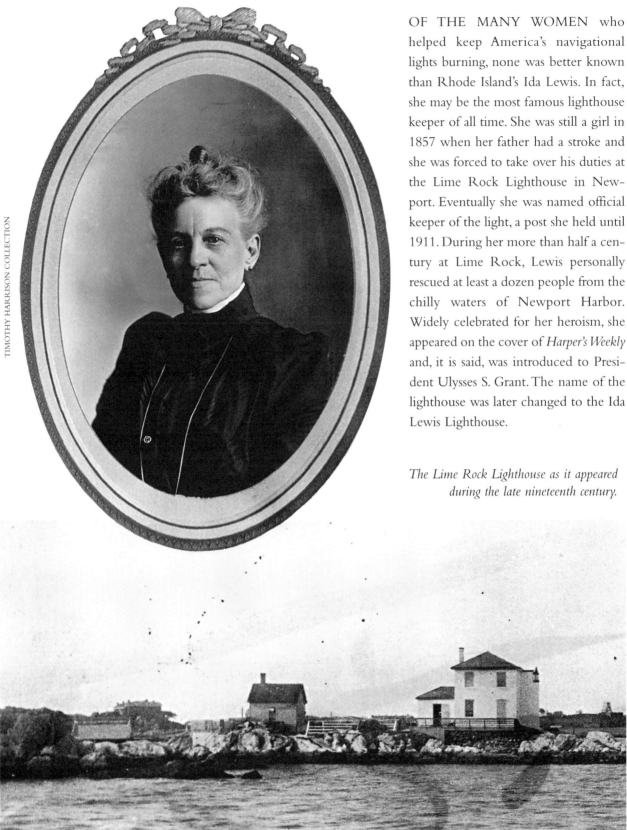

TIMOTHY HARRISON COLLECTION

OF THE MANY WOMEN who helped keep America's navigational lights burning, none was better known than Rhode Island's Ida Lewis. In fact, she may be the most famous lighthouse keeper of all time. She was still a girl in 1857 when her father had a stroke and she was forced to take over his duties at the Lime Rock Lighthouse in Newport. Eventually she was named official keeper of the light, a post she held until 1911. During her more than half a century at Lime Rock, Lewis personally rescued at least a dozen people from the chilly waters of Newport Harbor. Widely celebrated for her heroism, she appeared on the cover of *Harper's Weekly* and, it is said, was introduced to President Ulysses S. Grant. The name of the lighthouse was later changed to the Ida Lewis Lighthouse.

The Lime Rock Lighthouse as it appeared during the late nineteenth century.

TIMOTHY HARRISON COLLECTION

ANOTHER HEROIC "lighthouse lady" was Abbie Burgess, who grew up on remote Matinicus Rock, a twenty-acre island about two dozen miles off the coast of Maine. Abbie's father, Samuel Burgess, was keeper of the island's twin-towered lighthouse. Abbie was only seventeen years old in 1856 when her father sailed off to the mainland to pick up supplies and became trapped there by a winter storm that howled for nearly a month. For several weeks young Abbie faithfully tended the lights while caring for her invalid mother and two baby sisters. At times the storm sent waves crashing over the rock, forcing Abbie and the rest of the family to take refuge in the granite towers. Fortunately, except for one pet chicken swept into the ocean by the waves, the family survived the storm none the worse for the adventure. Abbie later married Isaac Grant (shown left on facing page), son of the man who replaced her father as keeper at Matinicus Rock. The couple spent most of their nearly thirty years together at the Whitehead Light Station (shown on facing page) south of Rockland, Maine.

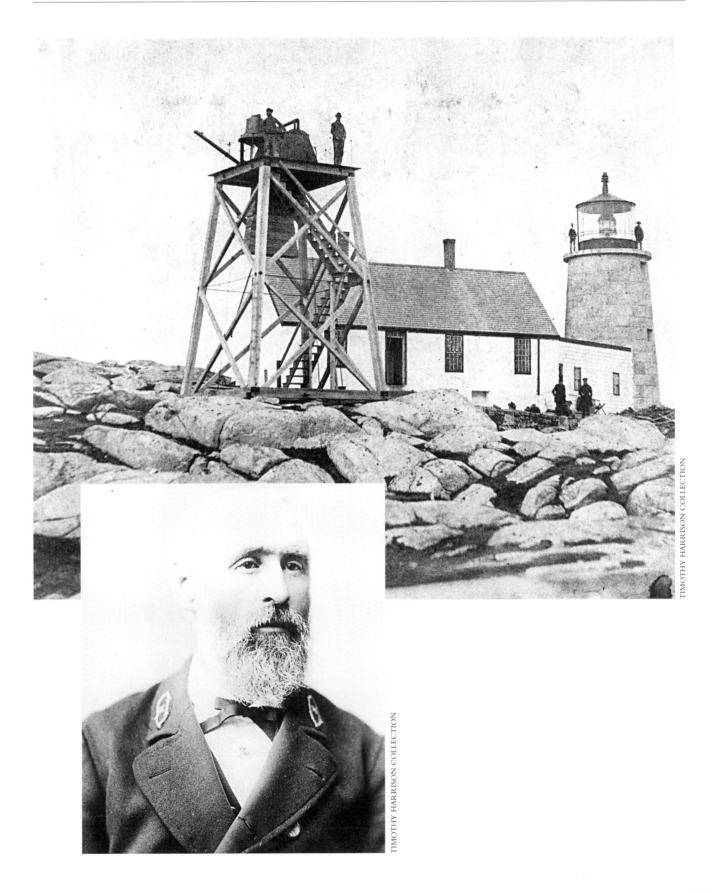

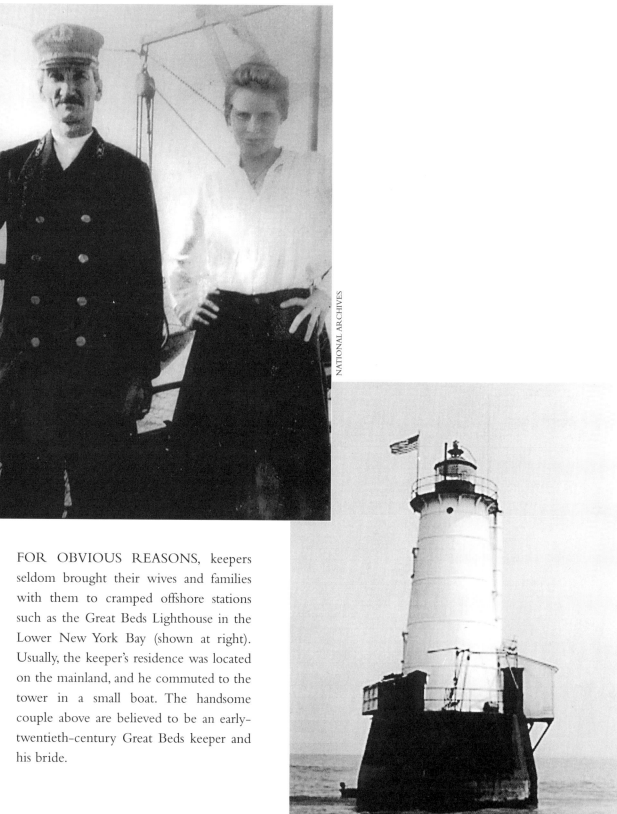

NATIONAL ARCHIVES

NATIONAL ARCHIVES

FOR OBVIOUS REASONS, keepers seldom brought their wives and families with them to cramped offshore stations such as the Great Beds Lighthouse in the Lower New York Bay (shown at right). Usually, the keeper's residence was located on the mainland, and he commuted to the tower in a small boat. The handsome couple above are believed to be an early-twentieth-century Great Beds keeper and his bride.

WHITE ISLAND LIGHTHOUSE AND KITCHEN

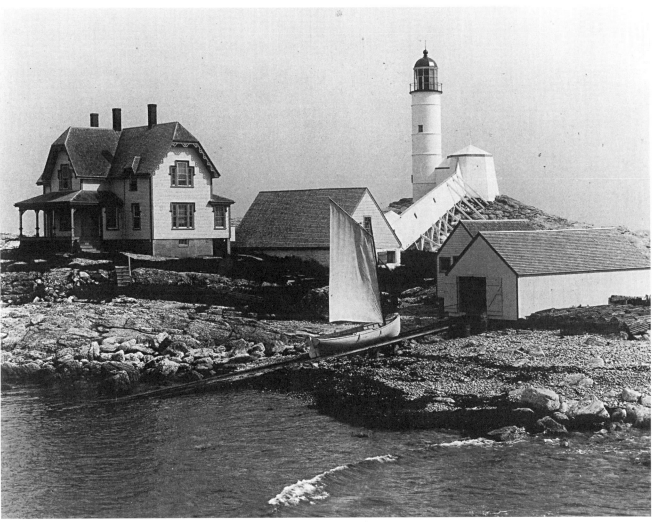

TIMOTHY HARRISON COLLECTION

MOST LIGHTHOUSE FAMILIES lived a simple but wholesome life, as the kitchen at the White Island Lighthouse suggests. The isolated White Island Station was established in 1820 to protect the outer edge of the Isle of Shoals, a group of small islands several miles east of Portsmouth, New Hampshire. The existing tower dates to 1859.

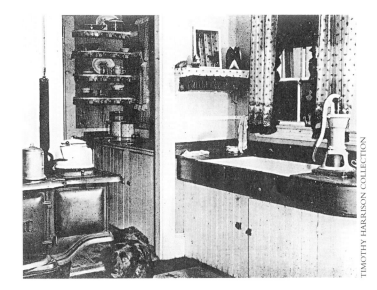

TIMOTHY HARRISON COLLECTION

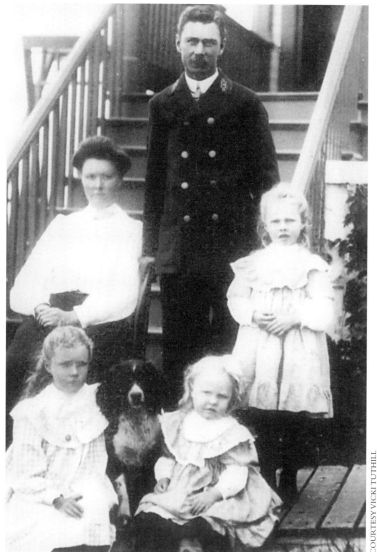

COURTESY VICKI TUTHILL

SOME KEEPERS raised large families in their remote but often quite comfortable homes. Keeper Albion Faulkingham poses with his wife, Lucy, daughters Marsha, Florence, and Dee Dee, and the family spaniel at Maine's Moose Peak Lighthouse. Below: An early view of the Moose Peak residence and tower.

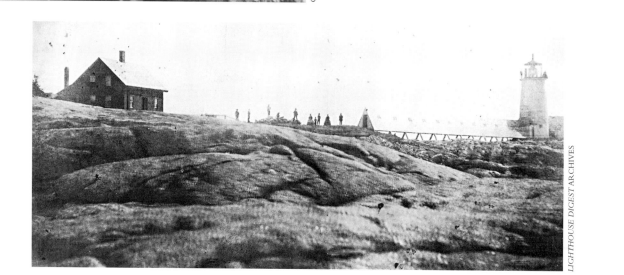

LIGHTHOUSE DIGEST ARCHIVES

CAPTAIN JOHN H. PAUL raised three sons at Dutch Island Light in Rhode Island's Narragansett Bay, where he was keeper from 1929 to 1931.

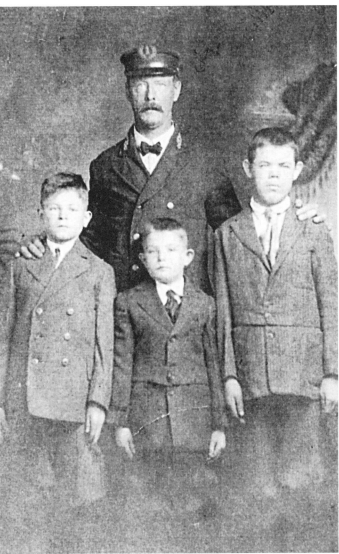

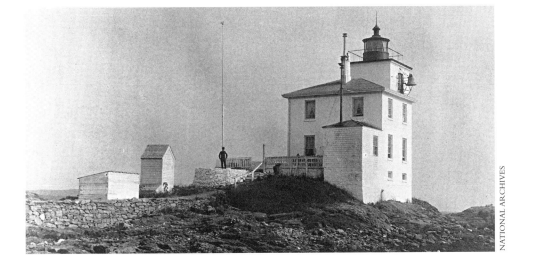

ELSON SMALL AND ST. CROIX LIGHTHOUSE

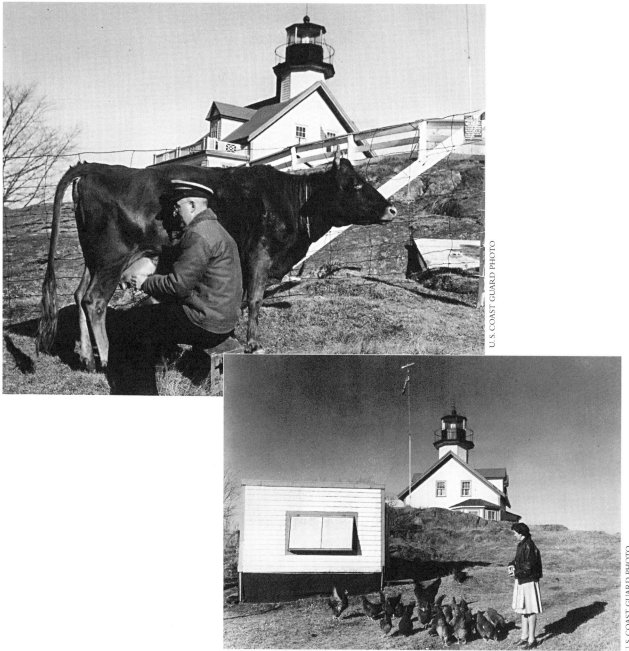

U.S. COAST GUARD PHOTO

U.S. COAST GUARD PHOTO

SINCE MOST LIGHT STATIONS WERE FAR FROM CITIES AND TOWNS, lighthouse life often had a distinctively rural flavor. Maine's St. Croix Lighthouse was located on the St. Croix River several miles from Calais, a community of only a few thousand. St. Croix keeper Elson Small, a career lighthouse man, maintained a close relationship with Blossom, the station cow. Small's wife, Connie, usually fed the chickens since she preferred to keep her distance from the temperamental Blossom. Years after the Smalls left St. Croix during the 1940s, Connie Small began to write and published a book about her experiences there and at other Maine lighthouses. She is now affectionately known as "The First Lady of Light."

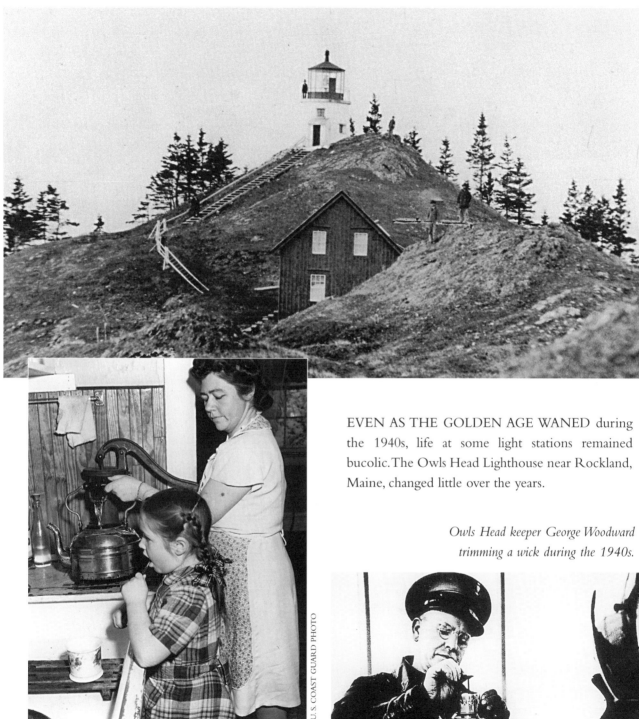

EVEN AS THE GOLDEN AGE WANED during the 1940s, life at some light stations remained bucolic. The Owls Head Lighthouse near Rockland, Maine, changed little over the years.

Owls Head keeper George Woodward trimming a wick during the 1940s.

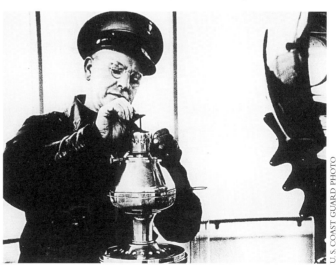

Above: A late 1890s view of the light station. Middle left: Woodward's wife and daughter take care of morning chores.

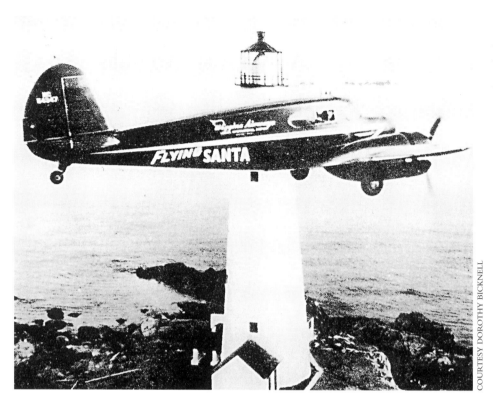

The Flying Santa, Edward Rowe Snow, pays a holiday visit to the Boston Harbor Lighthouse with its very tall "chimney."

IN 1929 PILOT BILL WINCAPAW got lost in the dark over Maine's broad Penobscot Bay. Wincapaw was able to recover his bearings and fly his small airplane to safety in Rockland by following a chain of lighthouse beacons along the coast. In gratitude to the lighthouse keepers who had unknowingly saved his life, Wincapaw made a practice of dropping Christmas packages from the air at light stations throughout the northeast. Later, pilot and author Edward Rowe Snow took over Wincapaw's role as the "Flying Santa" and continued it for several decades. The Flying Santa tradition is continued today by the nonprofit group Friends of the Flying Santa.

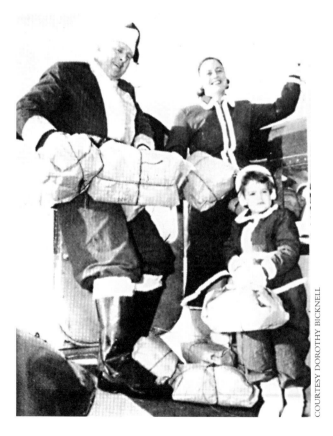

Snow loads Christmas packages with the help of his wife and daughter.

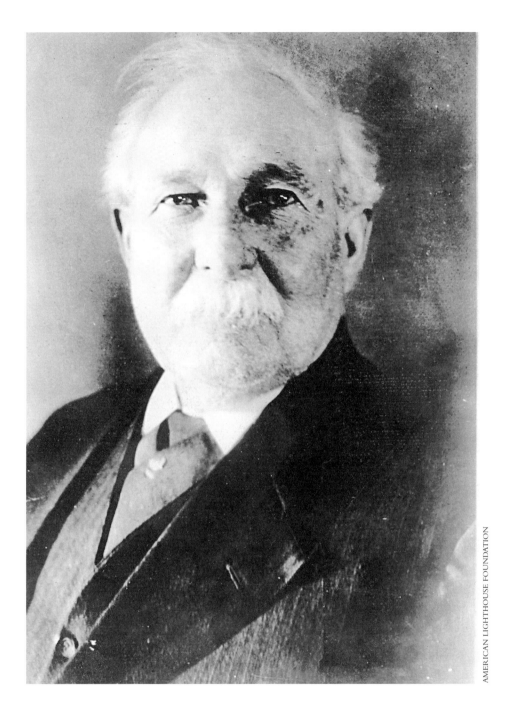

AMERICAN LIGHTHOUSE FOUNDATION

DURING THE EARLY TWENTIETH CENTURY, W. H. "GRANDPA" LAW traveled on lighthouse tenders to remote light stations, where he preached and ministered to keepers and their families. Some knew him as the "Sky Pilot to Lighthousemen."

TOWERS THROUGH TIME

Golden Age Lighthouses and How They Changed

MOST OF AMERICA'S LIGHTHOUSES have changed dramatically over the years and no longer look as they did a century or more ago. Towers have been raised, repainted, or pulled down and replaced with more modern structures. Keeper's dwellings have been enlarged, rebuilt, or removed all together. Fog signal buildings have been altered or fitted with new equipment.

Since the World War II era and the end of the period we describe as the golden age of lighthouses, nearly every light station has been automated. This, too, has brought changes, and not all of them for the better—from the point of view of those who love old lighthouses. In the process of adapting light stations to operation without day-to-day human assistance, the U.S. Coast Guard has removed lantern rooms, demolished storage buildings, and pulled down towers so that today many lighthouses live only in memory.

The archival photographs in this extended chapter depict more than fifty American light stations as they looked during the golden age. They also document in part the tides of change that have swept over the nation and its navigational lights during the last two centuries. The pictures and accompanying descriptive text are organized geographically beginning with Maine, moving down the East Coast to the Gulf of Mexico, and ending with the Great Lakes and the Far West.

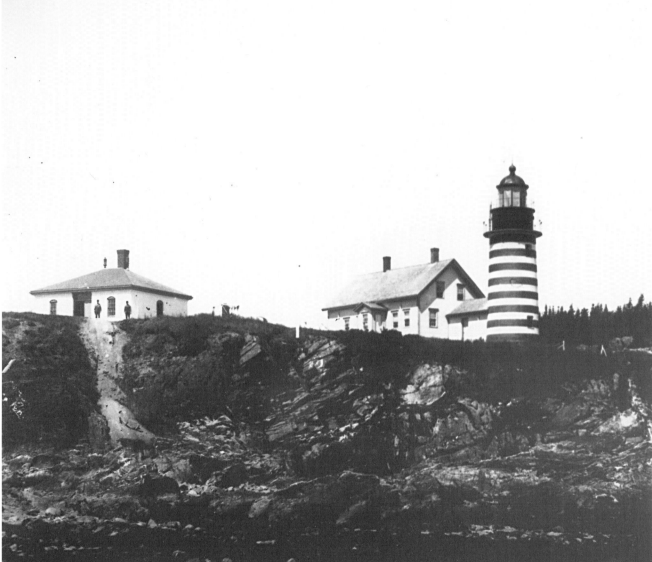

LOCATED ON THE EASTERNMOST POINT IN THE UNITED STATES, Maine's West Quoddy Lighthouse is so well known and loved that it has been featured on a postage stamp. The station looks much the same today as it did when this vintage photograph was taken, likely during the late nineteenth century. Look closely, however, and you'll notice that at the top of the tower a dark curtain has been drawn to shield the station's delicate Fresnel lens from the sun. Since the station was automated in 1988, there have been no keepers here to draw the curtain and handle day-to-day maintenance chores. The station is now part of a park and is open to the public.

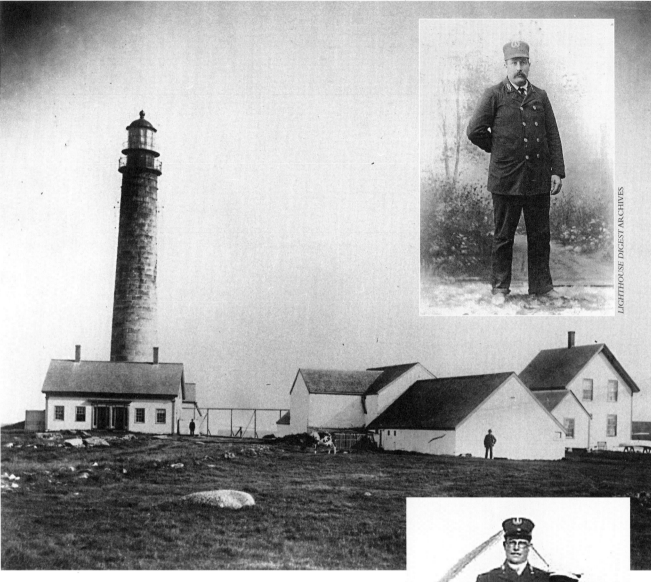

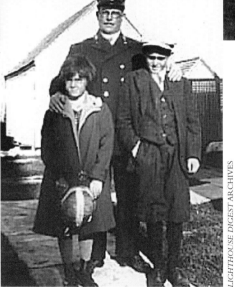

BUILT IN 1854, the slender granite tower of Maine's Petit Manan Light still stands, but many of the other structures in this early-twentieth-century view have vanished. Inset: Edmond Connors, an assistant keeper at Petit Manan from 1896 to 1903.

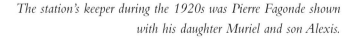

The station's keeper during the 1920s was Pierre Fagonde shown with his daughter Muriel and son Alexis.

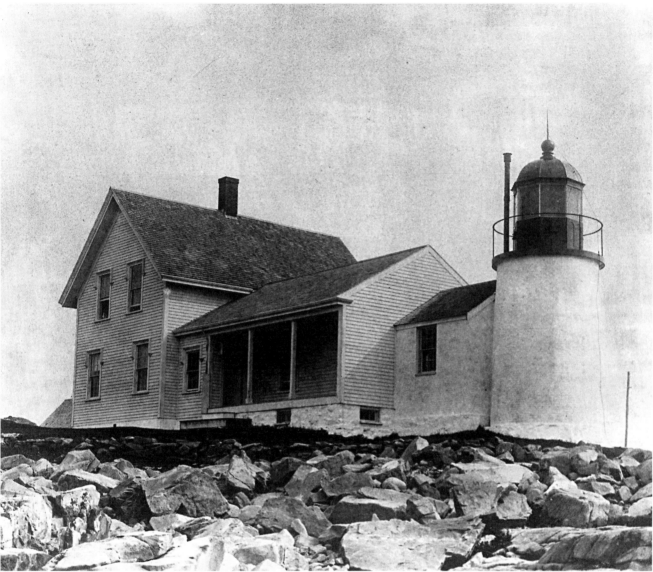

SHOWN HERE AS IT LOOKED ABOUT A CENTURY AGO, Winter Harbor Lighthouse has clung to its four-acre island since 1856. Although the lighthouse has been privately owned since 1934, its basic appearance has changed little.

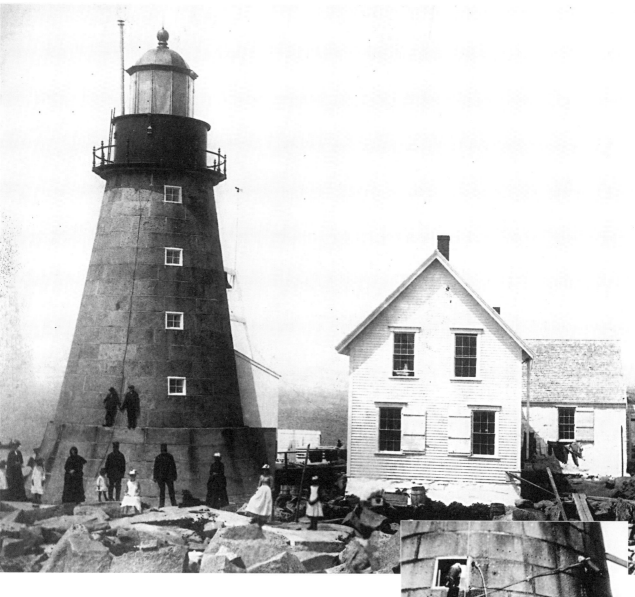

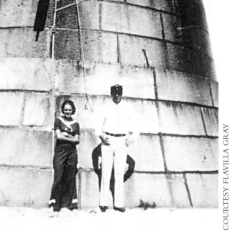

ALL DRESSED UP IN THEIR SUNDAY BEST, keepers and their families pose for a nineteenth-century photograph of the remote Mount Desert Rock Lighthouse. Established in 1830, the station had full-time keepers until 1977. Among them was Everett Quinn, shown at right with his daughter Flavilla in 1937.

TIMOTHY HARRISON COLLECTION

COURTESY FLAVILLA GRAY

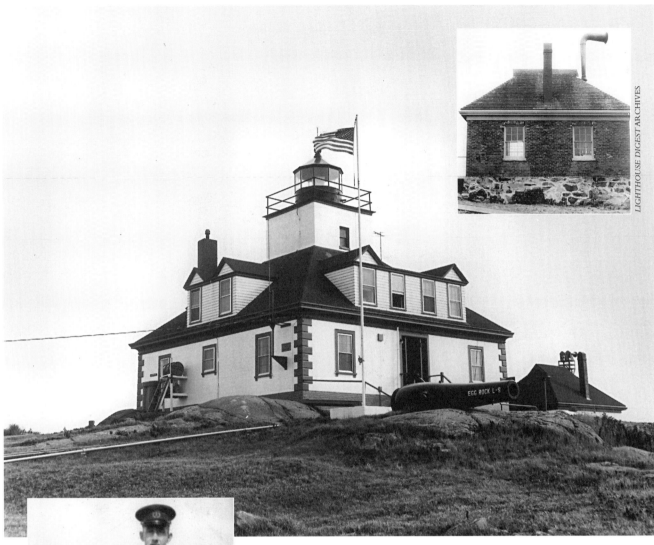

LIGHTHOUSE DIGEST ARCHIVES

U. S. COAST GUARD PHOTO

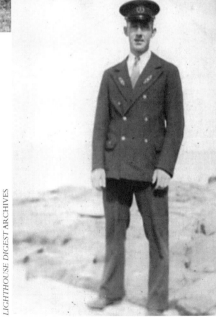

LIGHTHOUSE DIGEST ARCHIVES

VISITORS TO ACADIA NATIONAL PARK still enjoy watching for the red flash of the Egg Rock Light, but the station looks much different now than it did in this 1930s view. Inset: A steam-powered fog signal housed in this building once warned mariners away from the treacherous rock.

Egg Rock assistant keeper Clinton "Buster" Dalzell drowned in 1935 while going ashore to pick up some equipment.

NATIONAL ARCHIVES

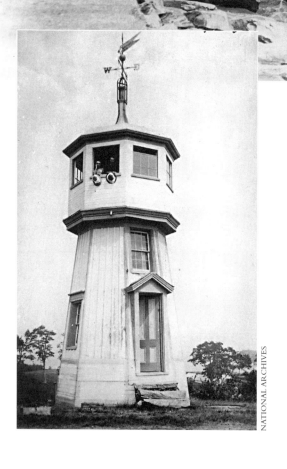

NATIONAL ARCHIVES

AFTER A DISASTROUS NOR'EASTER devastated Portland, the government built an extensive breakwater to protect the city's harbor. To guide vessels safely around this man-made obstacle, a small wooden lighthouse was placed at the seaward end of the breakwater in 1855. It is shown on the facing page with a man, likely as not the keeper, posing nonchalantly beside the gallery rail. Twenty years later the orginal lighthouse was replaced by a more substantial structure (above) consisting of a dwelling and an eleborately decorated cast–iron tower. In this photo a steamship and sailing vessel pass by the breakwater station. The old wooden lighthouse was then moved to the buoy station on Little Diamond Island for use as an observation tower. In the photograph at left the original lantern room has been moved and replaced by an observation deck.

U.S. COAST GUARD PHOTO

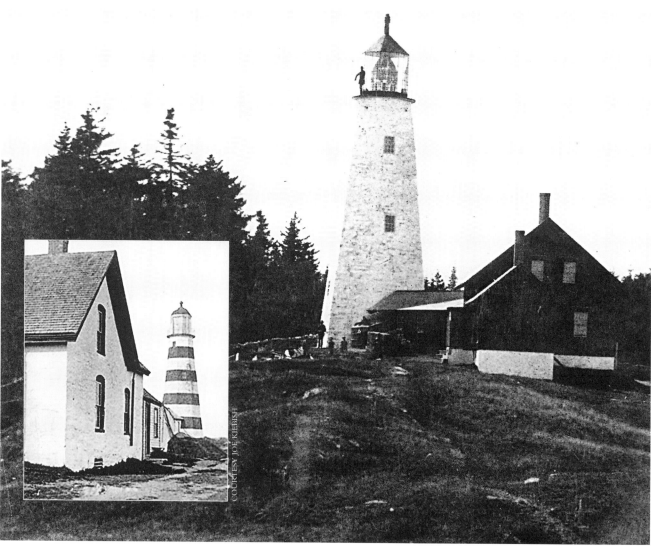

COURTESY JOE KIEBISH

COURTESY JOE KIEBISH

U. S. COAST GUARD PHOTO

IN 1828 THE FEDERAL GOVERN-MENT established a major twin-light navigational station at Cape Elizabeth south of Portland. Displayed from a pair of similar, though not identical, octagonal rubblestone towers, the double beacon was easy to distinguish from other nearby lights. The west tower (above) and its sister east tower (left) appear to have been built on sites hacked out of a forest wilderness. Eventually, the east tower was painted with

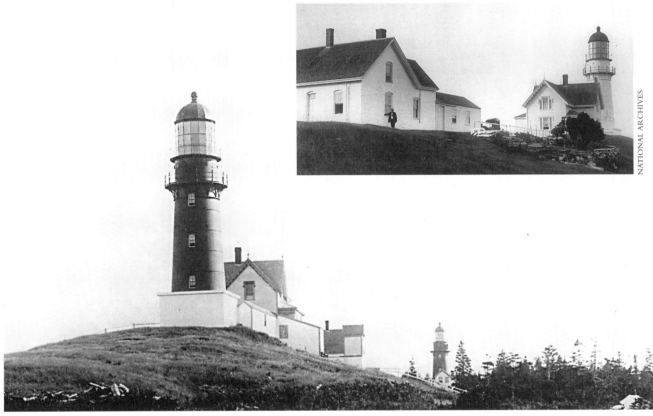

NATIONAL ARCHIVES

NATIONAL ARCHIVES

red and white horizontal stripes (see inset on opposite page). In 1874 the Lighthouse Board replaced the original stone structures with a pair of cast-iron cylindrical towers (above). An early-twentieth-century photograph (above inset) of the east tower features the Cape Elizabeth keeper leaning against a wall and his buggy parked near the station residence. After multiple beacons were phased out during the 1920s, the west tower (right) lost its lantern and, together with the adjacent residence, was sold to private owners.

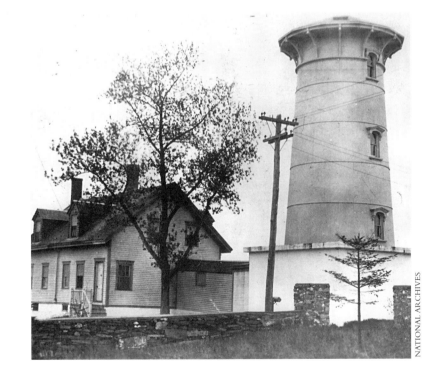

NATIONAL ARCHIVES

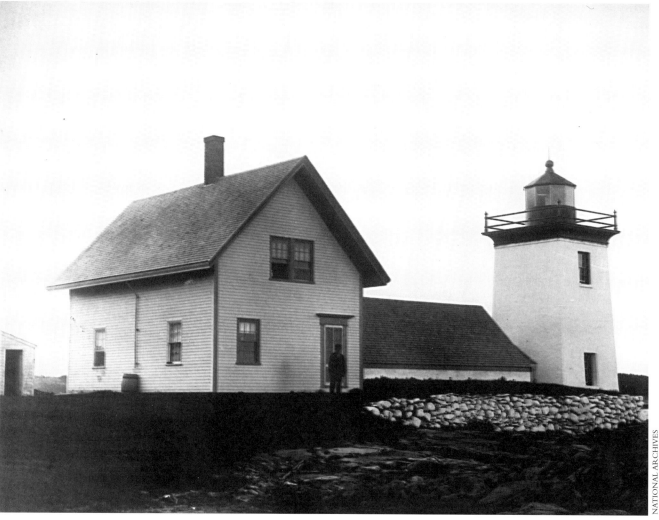

NATIONAL ARCHIVES

A 12-MILE-LONG ISLAND KNOWN AS ISLESBORO divides the upper reaches of Maine's Penobscot Bay into east and west channels. Since the middle of the nineteenth century, vessels navigating the west channel have relied on Islesboro's Grindle Point Lighthouse have for assistance. In 1874, the station's original tower (see page 38) was replaced by the structure shown in this photograph. Today, the lighthouse looks much the same as it did when it was completed nearly 130 years ago.

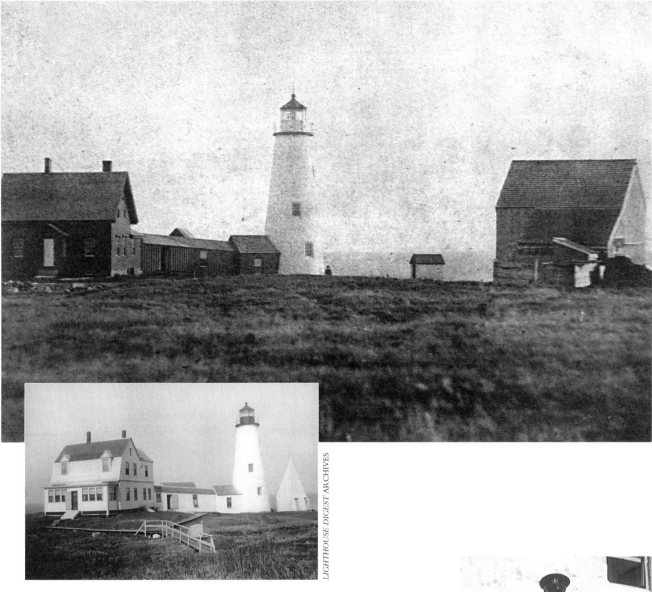

LIGHTHOUSE DIGEST ARCHIVES

LIGHTHOUSE DIGEST ARCHIVES

LIGHTHOUSE DIGEST ARCHIVES

THE VINTAGE PHOTOGRAPH OF THE WOOD ISLAND LIGHT STATION near Biddeford (top) dates to the mid-nineteenth century, while the much later photo (inset) was taken in 1936. An interval of more than eighty years separates the two images and spans nearly the entire golden age. When the Lighthouse Service was dissolved in 1939, Wood Island keeper Earle Benson (left) joined the Coast Guard and continued to keep the light until his retirement.

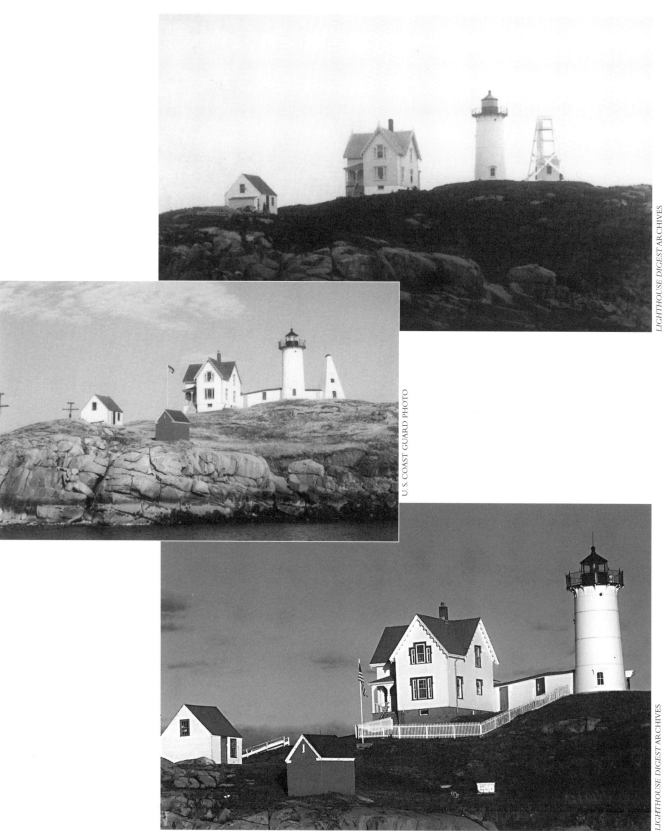

LIGHTHOUSE DIGEST ARCHIVES

U. S. COAST GUARD PHOTO

LIGHTHOUSE DIGEST ARCHIVES

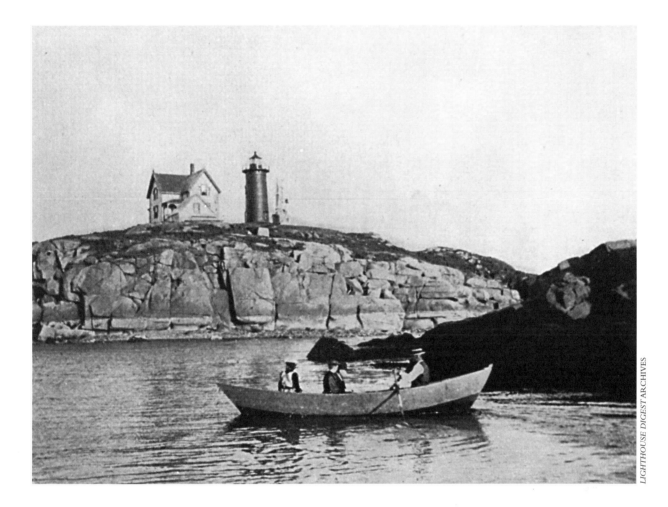

LIGHTHOUSE DIGEST ARCHIVES

AMONG THE BEST KNOWN and most often photographed lighthouses anywhere, the Cape Neddick (also known as the "Nubble") Light Station in York has survived fierce Atlantic storms and winter blizzards since 1879. Cresting a high, rocky island, the cast-iron tower and wood-frame residence seem almost to be daring the ocean to do its worst. The early 1900s view at the top of the facing page shows the station without the covered walkway, enclosed bell tower, and electric lines, all of which had been added by the time the 1940s photographs on the facing page (middle and bottom) were taken. No doubt keepers appreciated the protection of the walkway when they had to reach the tower or bell during stormy weather. A handsome and well-maintained historic treasure, the carefully restored lighthouse attracts its share of twenty-first-century visitors, but the station was already popular with tourists in the late nineteenth century. During the 1890s, keeper William Brooks earned pocket money by rowing visitors out to the island for ten cents a person (above). His wife charged an additional five cents for a tour of the house and tower.

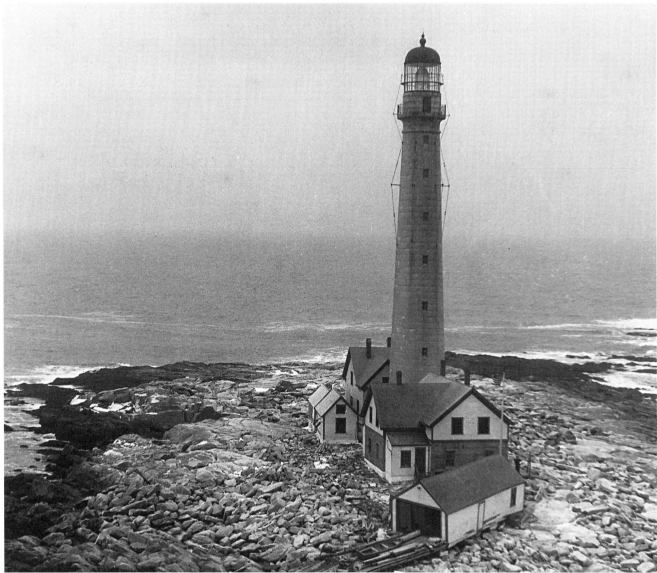

ONE OF THE LONELIEST and most remote light stations in New England, the Boon Island Lighthouse guards a notorious navigational obstacle that claimed its first ship almost 300 years ago. Several early towers marked the island, located about 6 miles off the southwest coast of Maine, but the existing 133-foot granite structure has stood since 1854. At least one keeper considered his assignment to this barren outpost equivalent to being "locked up in a cell." This photograph depicts the Boon Island Light Station as it looked during the 1930s. Today the tower is licensed to the nonprofit American Lighthouse Foundation for future care and maintenance.

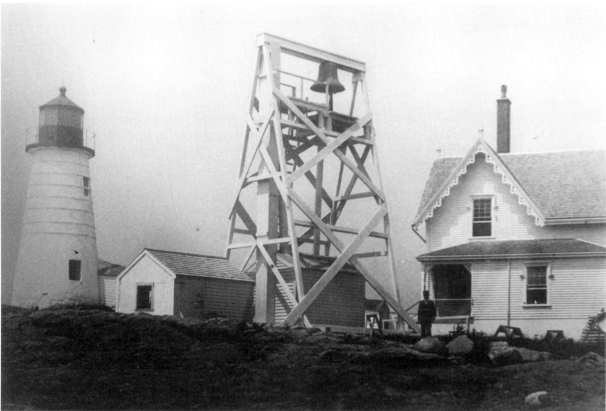

NATIONAL ARCHIVES

ALONG THE EAST SIDE of the harbor at Gloucester, a rocky promontory forms both a natural breakwater and an ideal site for a light station—one was established there in 1832. Likely taken about 1880, the photograph above shows the original stone tower and a recently completed Victorian-style residence, with the keeper standing in front. The bell tower probably dates from the 1850s. The stone tower gave way to a brick structure in 1890.

The station as it looks today.

JEREMY P. D'ENTREMONT

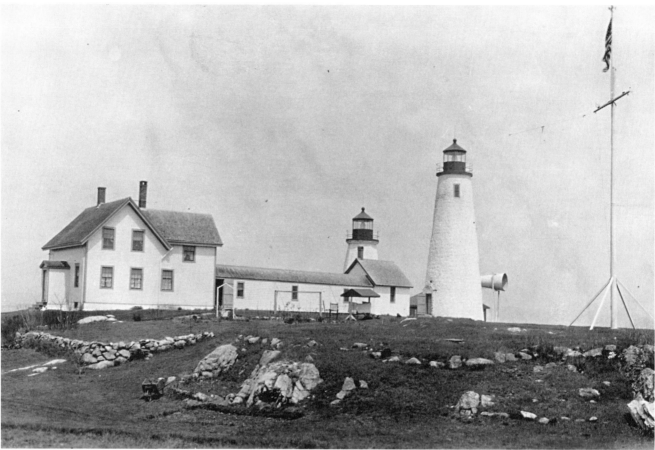

AMONG THE FIRST TWIN-BEACON NAVIGATIONAL STATIONS IN AMERICA, the first Baker's Island Light was built in 1798 during the presidency of John Adams. The original wooden towers stood on the roof of the keeper's dwelling, but they were replaced by the stone towers shown here in 1820. After the Lighthouse Service stopped using multiple lights during the 1920s, the shorter tower (shown in the background of this photograph) was demolished.

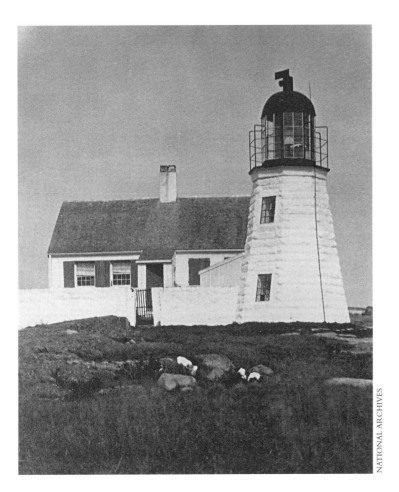

NATIONAL ARCHIVES

ACCORDING TO LEGEND, the settlers who founded Gloucester bought Ten Pound Island from the Indians for exactly ten pounds in English currency; hence the name. The island became famous in 1817, when Gloucester residents reported sighting a giant sea serpent sunbathing on its rocks. The serpents had vanished into the sea—or into thin air—by the time the government established a light station on Ten Pound Island about 1820. Shining from atop an octagonal stone tower, its beacon guided fishing boats and other vessels through the inner Gloucester harbor for more than sixty years. In 1881 the original tower was replaced by a cast-iron structure raised adjacent to a two-story wood-frame keeper's residence (below left). During Prohibition in the 1920s, a Coast Guard Station on Ten Pound Island kept watch for rum runners using a seaplane like the one shown below.

TIMOTHY HARRISON COLLECTION

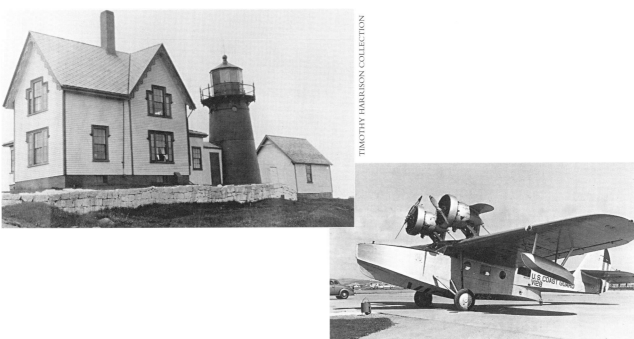

TIMOTHY HARRISON COLLECTION

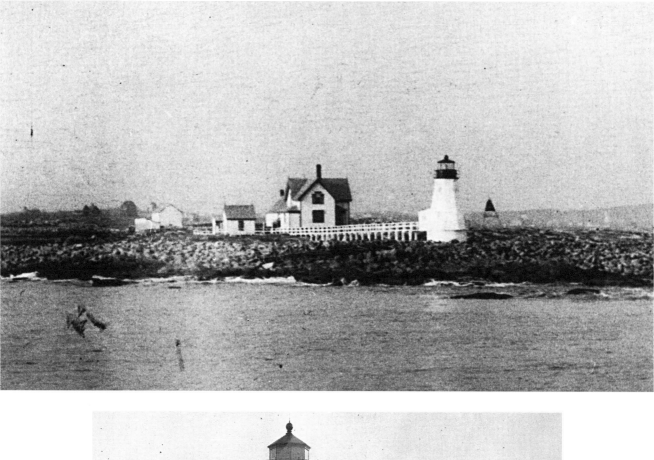

NATIONAL ARCHIVES

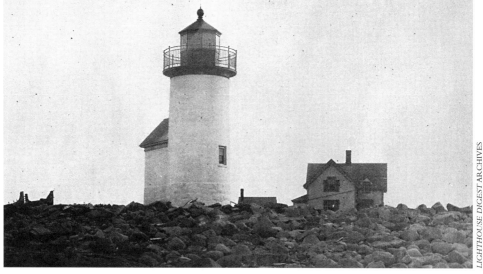

LIGHTHOUSE DIGEST ARCHIVES

AN ANTIQUE PICTURE of the Straitsmouth Island Lighthouse (top, see also page 42) near Rockport shows the old 1835 octagonal tower with walkway and keeper's residence. The tower was demolished in 1896 and replaced by the cylindrical structure (bottom), which still stands.

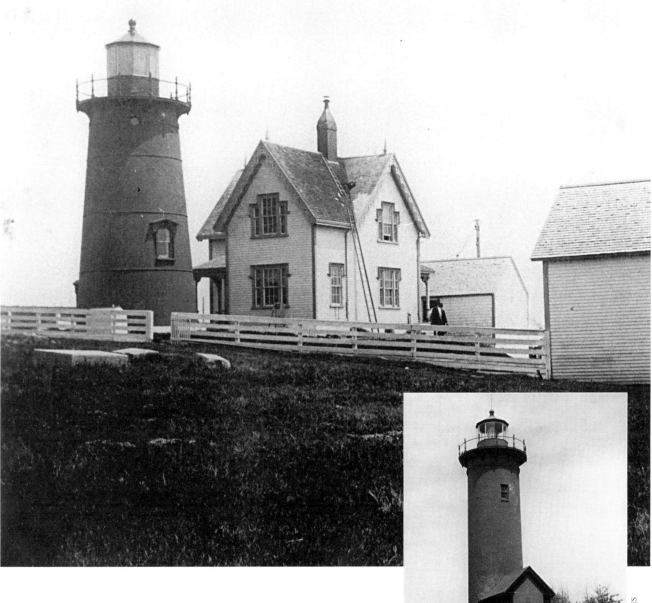

SEVERAL DIFFERENT TOWERS have marked Long Island Head in inner Boston Harbor. The nation's first cast-iron tower replaced an earlier structure here in 1844 (see page 33). The existing tower (below right) dates to 1901. A bizarre story is told concerning the funeral of keeper Edwin Tarr, who died on duty in 1918. Four pallbearers, who came to take away the keeper's remains during a winter ice storm, slipped on the ice and dropped the coffin, which began to slide downhill. Several of Tarr's friends tried to stop the runaway coffin by piling on top of it, but they were unsuccessful and ended up tobogganing all the way to the station wharf.

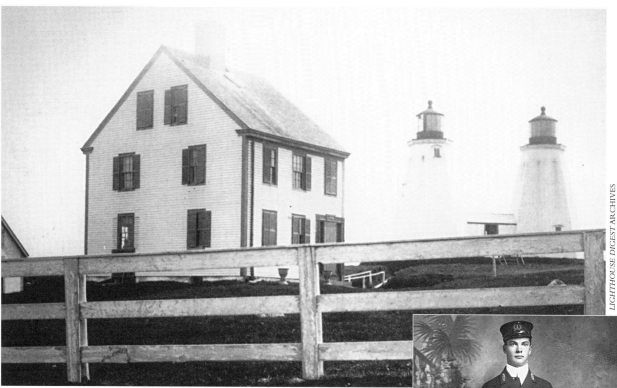

LIGHTHOUSE DIGEST ARCHIVES

ESTABLISHED IN 1769, the Plymouth Lighthouse is one of the oldest navigational stations in America and was the first to employ twin lights. For many years the lights were displayed in a matched pair of lanterns resting on the roof of the keeper's residence. In 1803 the station received two separate towers, which were replaced in 1843 by the octagonal wooden towers shown above. One of the towers was torn down after the Lighthouse Service extinguished its light in 1924.

LIGHTHOUSE DIGEST ARCHIVES

A direct descendant of Mayflower pilgrims, Frank Allen Davis served as Plymouth Lighthouse keeper for seventeen years.

LIGHTHOUSE DIGEST ARCHIVES

A Plymouth keeper poses with his loved ones.

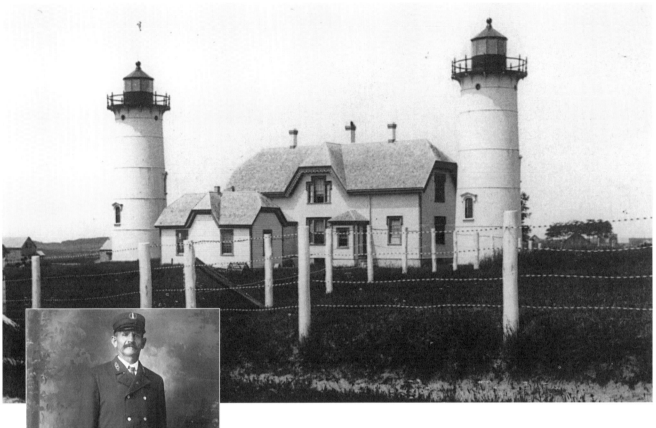

LIGHTHOUSE DIGEST ARCHIVES

THE CHATHAM LIGHT ON CAPE COD once had a pair of towers rather than just one as it does today. The tower on the left was moved to Nauset in 1923.

LIGHTHOUSE DIGEST ARCHIVES

Above: James Thurston Allison was keeper during the 1920s.

LIGHTHOUSE DIGEST ARCHIVES

Captain Josiah Hardy kept the Chatham Lights from 1872 until 1900.

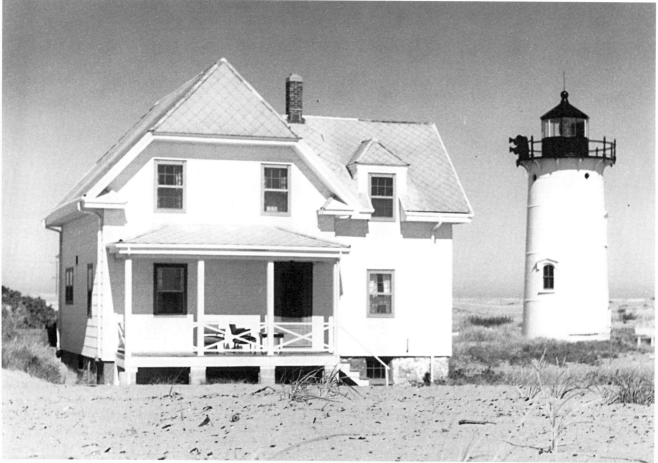

CAPE COD'S RACE POINT LIGHT-HOUSE pictured above (see also page 28) in 1940 at the end of the golden age. The residence was occupied until the station was automated in 1978. Recently refurbished by the American Lighthouse Foundation, the residence is now available for overnight stays.

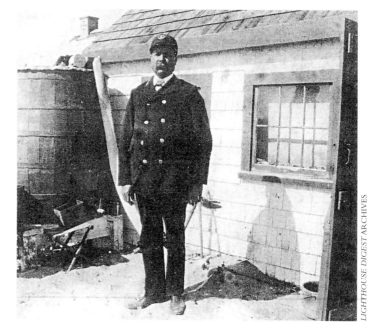

Early-twentieth-century Race Point keeper Captain "Big" John MacKenzie. Notice the whale jaw and rain barrel cistern on the left.

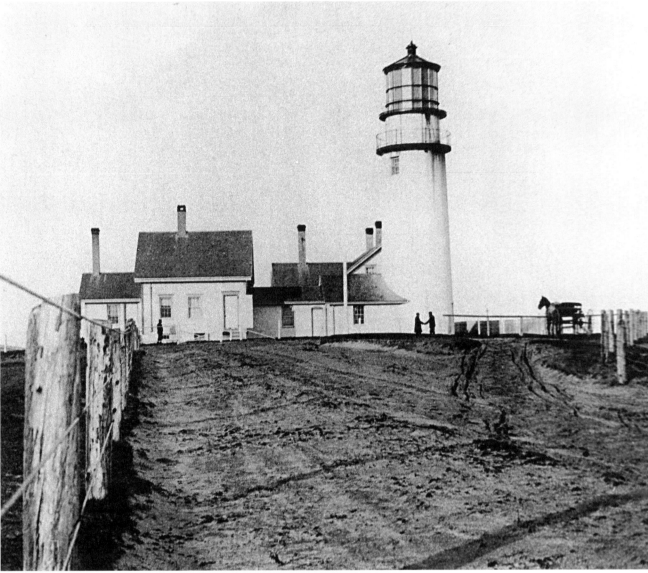

AN 1890s, HORSE-AND-BUGGY-DAYS VIEW of the famous Highland Light on Cape Cod shows the 1856 tower much as it looks today. However, the old tower is no longer located on the site shown here. Threatened by erosion during the 1990s, it was moved several hundred feet back from the crumbling bluffs.

TIMOTHY HARRISON COLLECTION

BUILT IN 1855, the Bass River Lighthouse in West Dennis looked like this at the turn of the twentieth century but is much changed nowadays. Considerably expanded, it serves as the central section of a comfortable seaside inn.

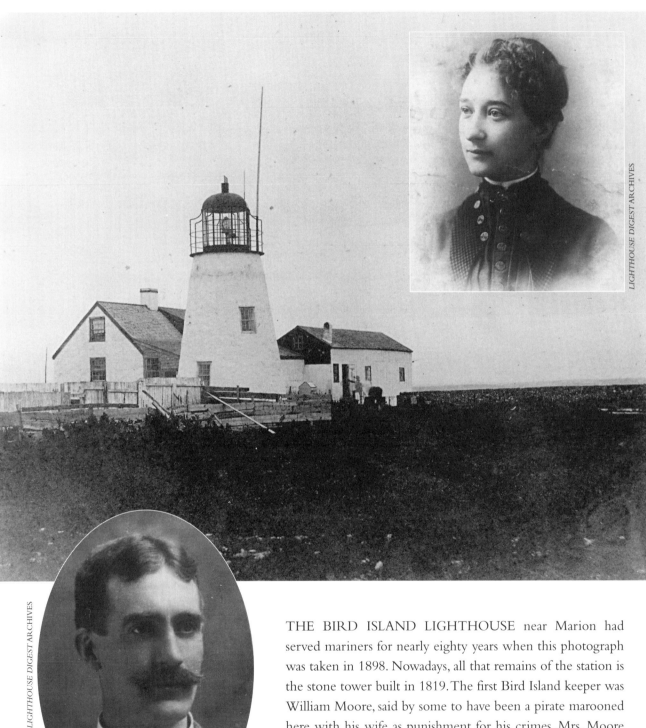

LIGHTHOUSE DIGEST ARCHIVES

U.S. COAST GUARD PHOTO

LIGHTHOUSE DIGEST ARCHIVES

THE BIRD ISLAND LIGHTHOUSE near Marion had served mariners for nearly eighty years when this photograph was taken in 1898. Nowadays, all that remains of the station is the stone tower built in 1819. The first Bird Island keeper was William Moore, said by some to have been a pirate marooned here with his wife as punishment for his crimes. Mrs. Moore eventually disappeared, and some on the mainland believed the old pirate had murdered her. A century later, a more loving couple came to Bird Island: keeper H. H. Davis (left) and his wife, Elizabeth (inset above).

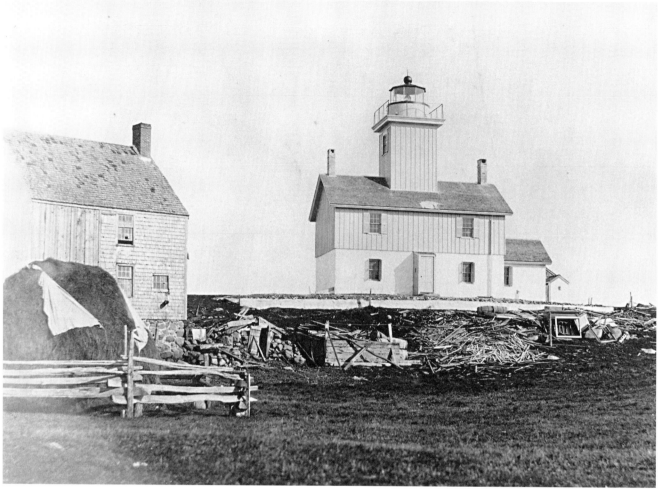

BUILT IN 1823, the original Cuttyhunk Light on Buzzards Bay consisted of a 25-foot-tall stone tower and adjacent keeper's residence. By 1860, the old tower had been removed and a new one placed atop the former residence (above). Thirty years later, the station was reconfigured once again, this time with a conical tower and separate residence, possibly the old 1823 dwelling remodeled yet again (right). Severely damaged by a 1944 hurricane, the entire station was torn down and removed.

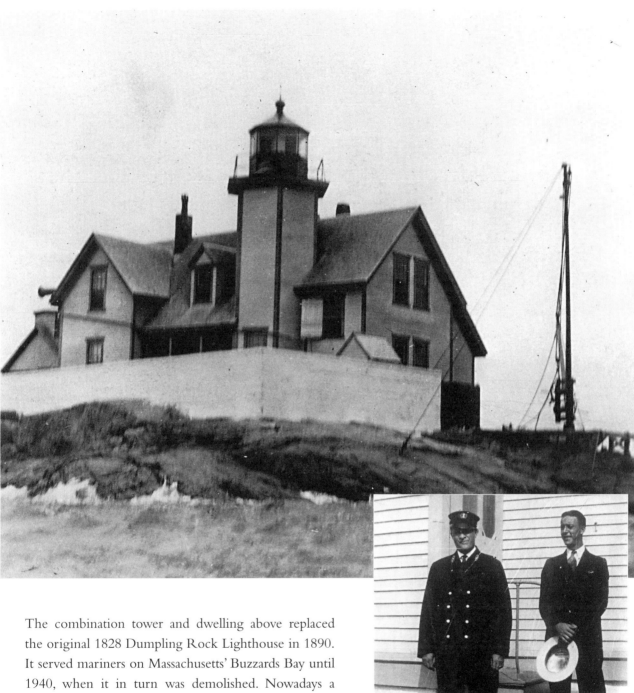

The combination tower and dwelling above replaced the original 1828 Dumpling Rock Lighthouse in 1890. It served mariners on Massachusetts' Buzzards Bay until 1940, when it in turn was demolished. Nowadays a skeleton tower marks the rock. Dressed in his Lighthouse Service uniform, John Strout (inset) poses with an associate at Dumpling Rock in 1931. A member of the famed lighthouse family that lived for many years at the Portland Head Lighthouse in Maine, Strout served here briefly as keeper during the 1930s.

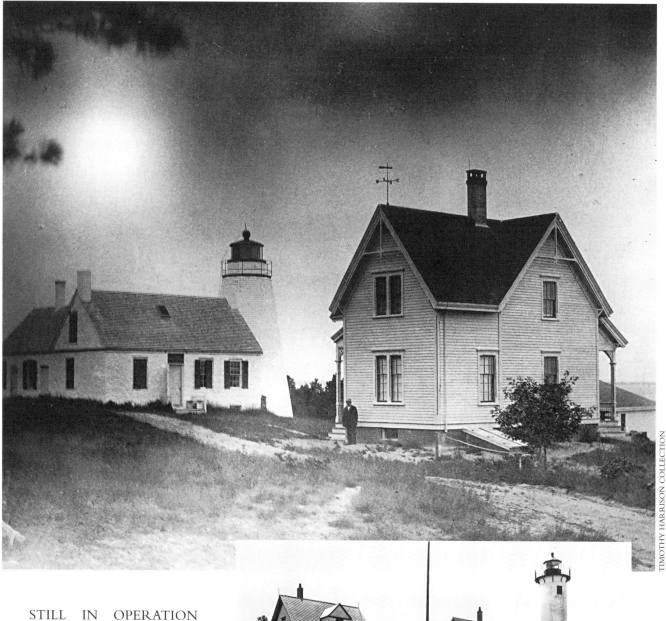

TIMOTHY HARRISON COLLECTION

STILL IN OPERATION today, the West Chop Light guides vessels to a key harbor on Martha's Vineyard. The haunting photograph (above) depicts the station as it looked in 1879, much changed from its appearance earlier in the nineteenth century (see page 29).

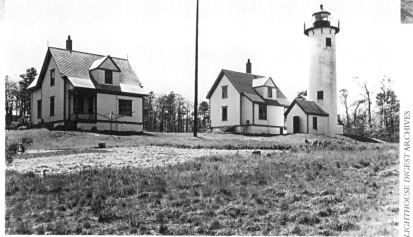

LIGHTHOUSE DIGEST ARCHIVES

The structures shown date to 1891.

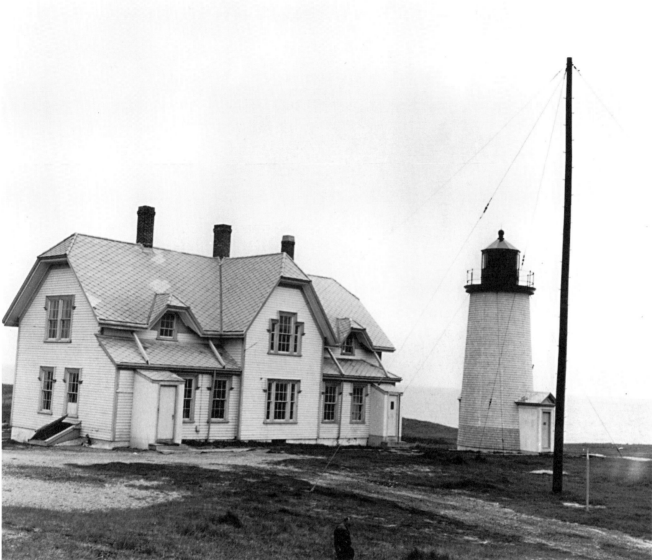

THE 1893 WOOD SHINGLE TOWER at Cape Poge (see also page 36) on Chappaquiddick Island near Edgartown still stands and its light remains in operation. Unfortunately, the station's remarkable Victorian residence was demolished during the 1950s and sold as lumber.

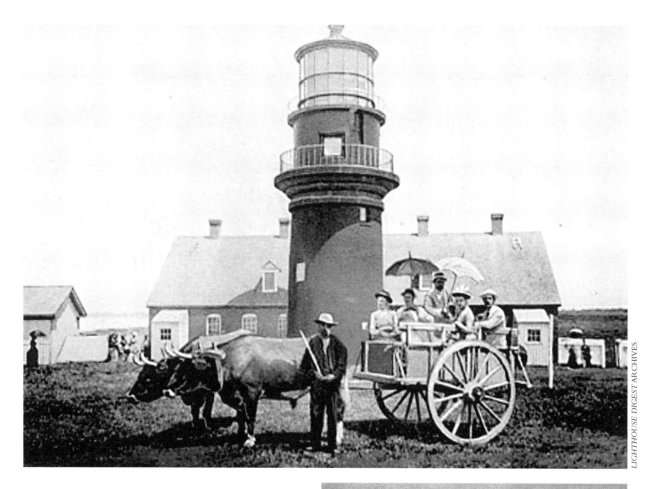

HOLIDAY VISITORS ENJOYED THE GAY HEAD LIGHT just as much during the nineteenth century as they do nowadays. However, travelers today are much more likely to get there in an automobile than by way of oxcart. Built in 1856, the station's massive brick tower still stands, but all its support buildings have been removed.

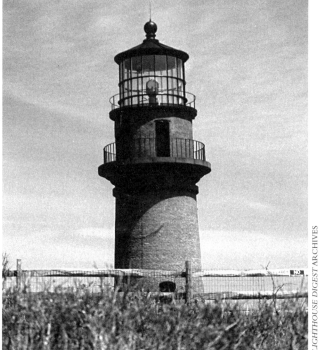

A recent view of the tower.

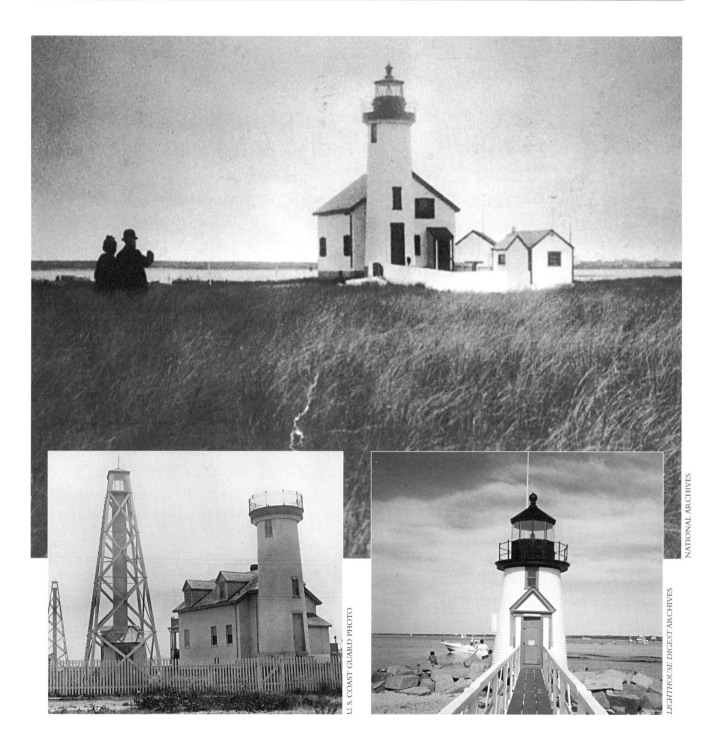

AS MANY AS TEN DIFFERENT LIGHT TOWERS have marked Brant Point near the entrance to Nantucket's main harbor. The brick tower and residence (top) date to 1856. In the early-twentieth-century view (bottom left), the lantern room has been removed and a pair of skeleton towers erected for the display of range lights. The range towers are gone, but the 1856 structure still stands. The small tower (lower right) provides the Brant Point beacon today.

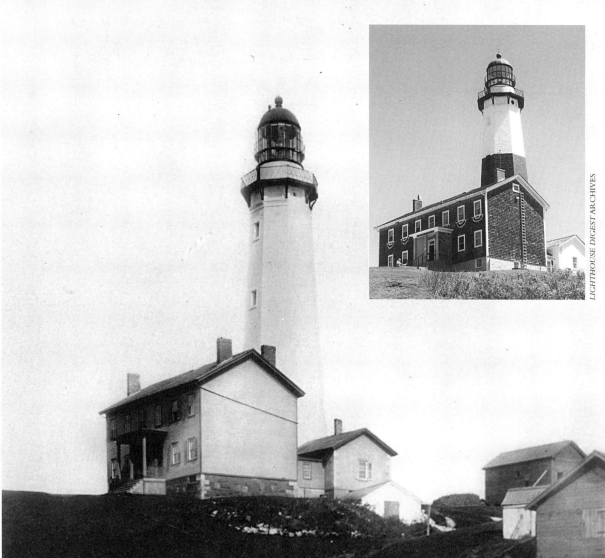

LIGHTHOUSE DIGEST ARCHIVES

LIGHTHOUSE DIGEST ARCHIVES

OFTEN THE FIRST SHORE LIGHT SEEN by passengers arriving on trans-Atlantic liners, Long Island's Montauk Point beacon has welcomed countless immigrants to the United States, and many see it as an American symbol no less important than the Statue of Liberty. President George Washington authorized construction of the sandstone tower, which was completed in 1797. The older photograph depicts the Montauk Point Light as it appeared about a century ago, before the tower received its distinctive black band, while the inset shows the station as it looks today.

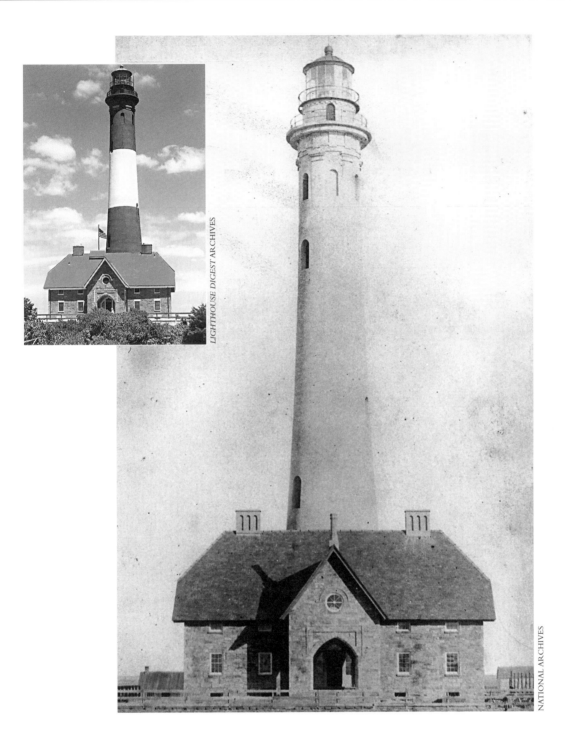

LIKE ITS NEIGHBOR AT MONTAUK POINT about 80 miles to the east, the 1858 Fire Island Light tower was originally all one color—yellow. During the 1890s, the Lighthouse Board had it painted with alternating black and white bands. The government planned to demolish the old tower in 1982, but thanks to the protests and hard work of local preservationists, it remains standing.

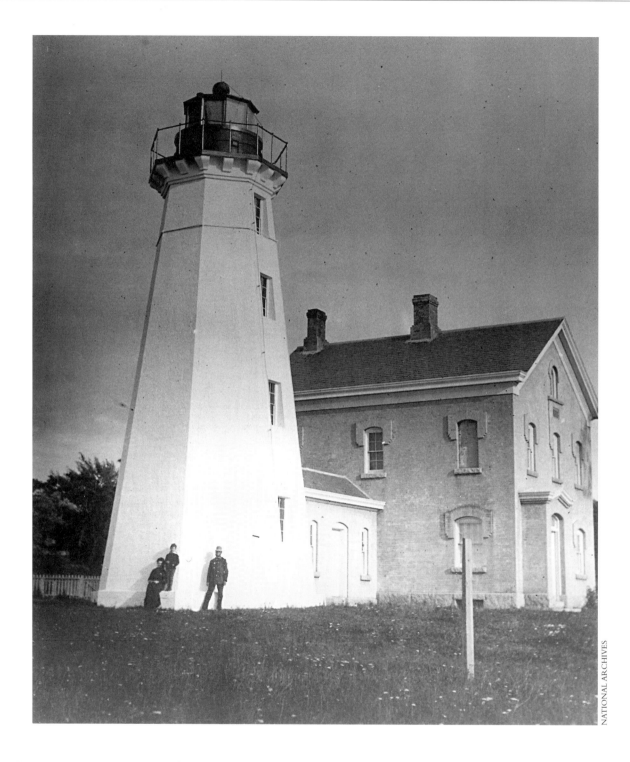

NATIONAL ARCHIVES

DEACTIVATED IN 1922, the Sand Point Light near the western end of Long Island has been privately owned for more than eighty years. This is how it looked in 1884.

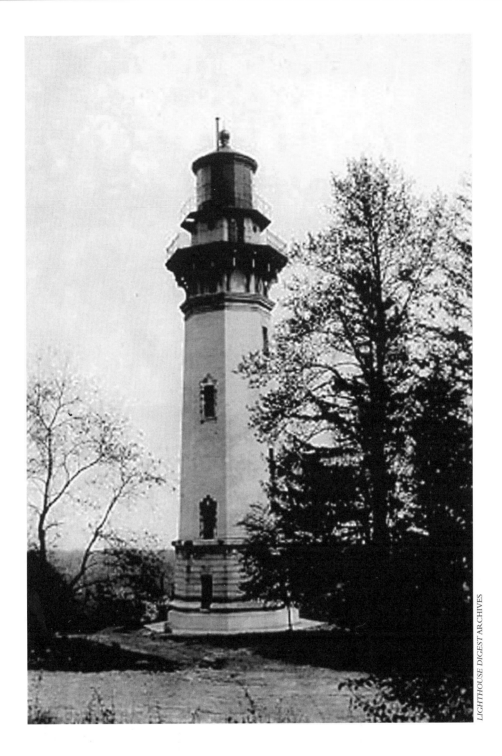

ESTABLISHED IN 1912, the same year the *Titanic* struck an iceberg in the North Atlantic and sank, the Staten Island Light remains active. The yellow brick octagonal tower still looks much like it did when this photograph was taken during the station's early years of operation.

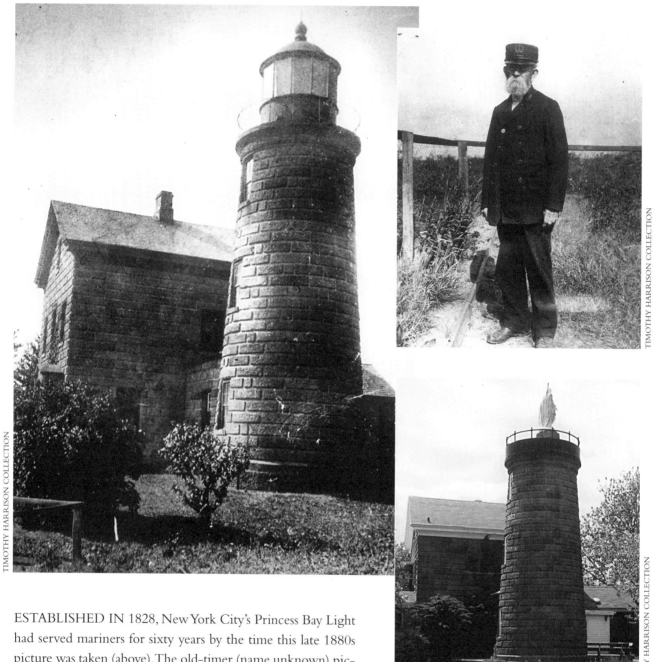

TIMOTHY HARRISON COLLECTION

TIMOTHY HARRISON COLLECTION

TIMOTHY HARRISON COLLECTION

ESTABLISHED IN 1828, New York City's Princess Bay Light had served mariners for sixty years by the time this late 1880s picture was taken (above). The old-timer (name unknown) pictured at upper right served as keeper here before the station was sold for use as a religious mission house during the 1920s.

The Princess Bay lantern room has been replaced by a statue of the Virgin Mary.

NEW YORK: FORT WADSWORTH AND FORT TOMPKINS LIGHTS

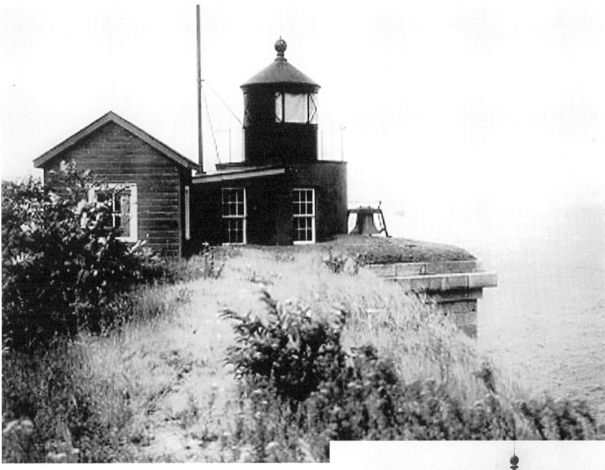

SIZE CAN BE DECEIVING. The diminutive lighthouse poised on the walls of Fort Wadsworth above was far more important to mariners than its modest stature suggests. This small but vital navigational station overlooked New York's strategic Verrazano Narrows, and during the early twentieth century, its beacon guided countless thousands of freighters to wharves in New York City and along the Hudson. Built in 1902, the Fort Wadsworth Lighthouse took the place of a far more elaborate Victorian-style lighthouse (right) at nearby Fort Tompkins. The beautiful Fort Tompkins Lighthouse no longer stands.

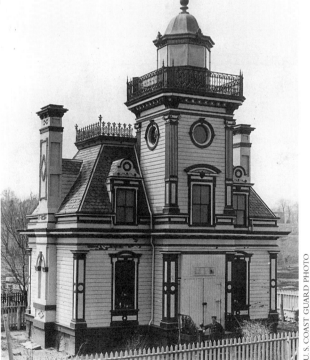

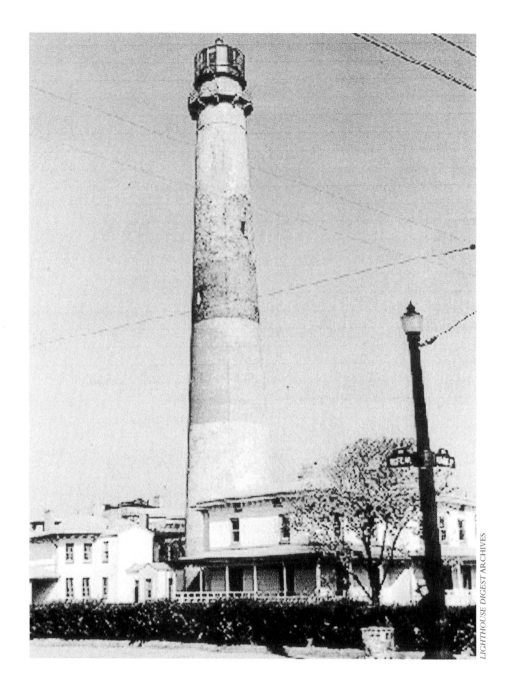

LIGHTHOUSE DIGEST ARCHIVES

ATLANTIC CITY'S historic 1867 Absecon Lighthouse already shows signs of deterioration in this early-twentieth-century view. Restoration work, ongoing since 1997, has saved the tower and is turning it into an attractive destination for tourists and lighthouse lovers.

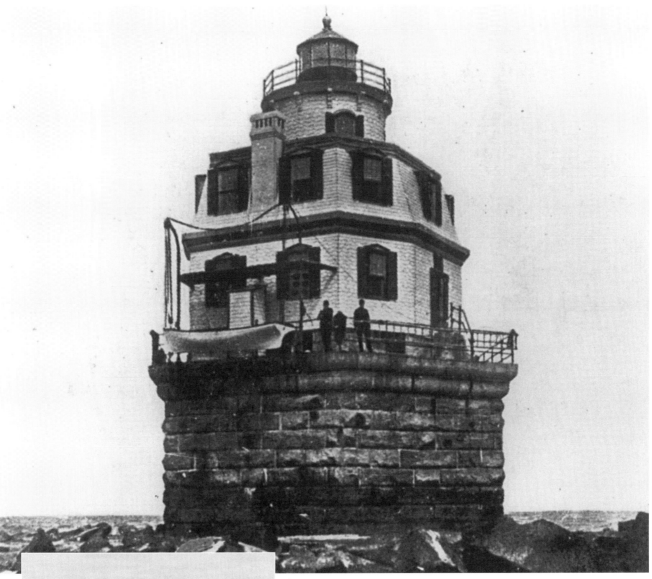

COURTESY ROBERT J. LEWIS

COURTESY ROBERT J. LEWIS

BUILT IN 1875, the open-water Cross Ledge Lighthouse in Delaware Bay served for only thirty-five years. Discontinued in 1910, it was torn down in 1953. All that remains of it today is the granite base now known by locals as the "rock pile."

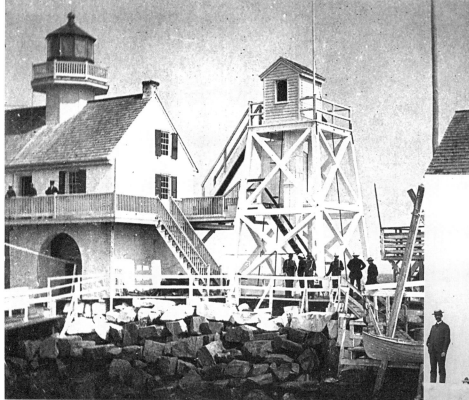

TO PROTECT SHIPS seeking refuge from Atlantic storms, the government began construction of the massive Delaware Breakwater just west of Cape Henlopen during the late 1820s. Begun during the presidency of John Quincy Adams, the breakwater took more than forty years to build. When complete, it was more than 3,600 feet long and was constructed using 835,000 tons of stone. To guide vessels into the safe harbor it protected, lighthouses were built at either end of the breakwater. The west end was occupied by a rather substantial light station, shown above as it looked in 1885. At first, the east end was marked by a modest wooden tower (above right)—the seated figure is likely a lighthouse inspector. Eventually, it was replaced by the cast-iron tower shown at right, with the lighthouse tender *Iris* anchored nearby.

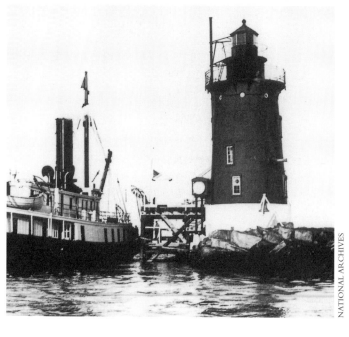

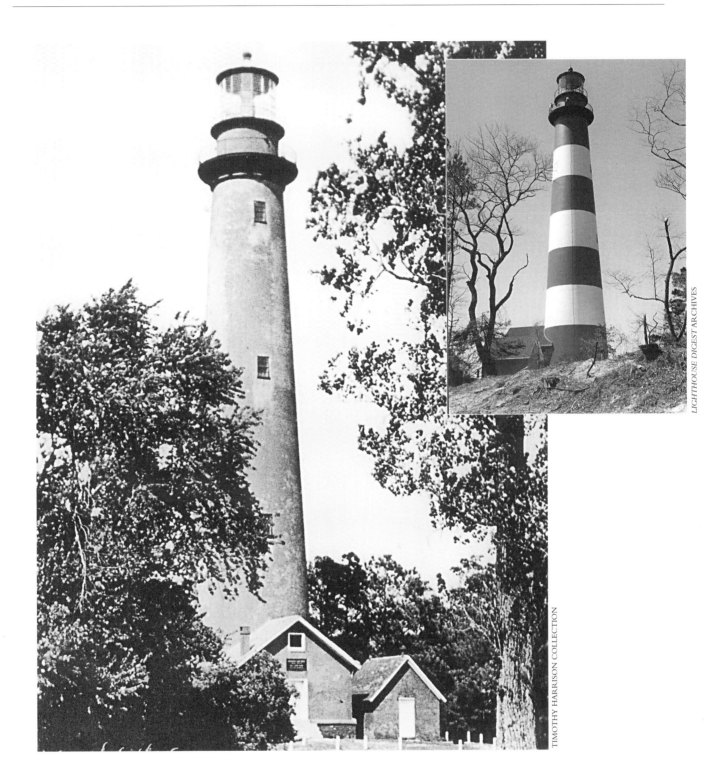

LIGHTHOUSE DIGEST ARCHIVES

TIMOTHY HARRISON COLLECTION

THE SOARING 145-FOOT-TALL BRICK TOWER on Virginia's Assateague Island was originally solid in color, but nowadays it is painted with red and white bands.

NATIONAL ARCHIVES

VIRGINIA BEACH TOURIST DEVELOPMENT DIVISION

FEW AMERICAN BUILDINGS can lay claim to more history than the octagonal sandstone light tower on Cape Henry near the entrance to Chesapeake Bay. One of the first major projects undertaken by the U.S. government, it was built by order of President George Washington with funds set aside by Secretary of the Treasury Alexander Hamilton. Completed in 1792, the Cape Henry Lighthouse guided mariners into the bay for nearly ninety years, but after large cracks appeared in its walls, the Lighthouse Board decided to replace it. An 1881 photograph (above) shows the original lighthouse and the new cast-iron tower under construction. Metal plates and equipment litter the site. A view of the station as it looks today includes both the 1881 tower and its much older neighbor, which remained standing despite the cracks and serves as a historic attraction.

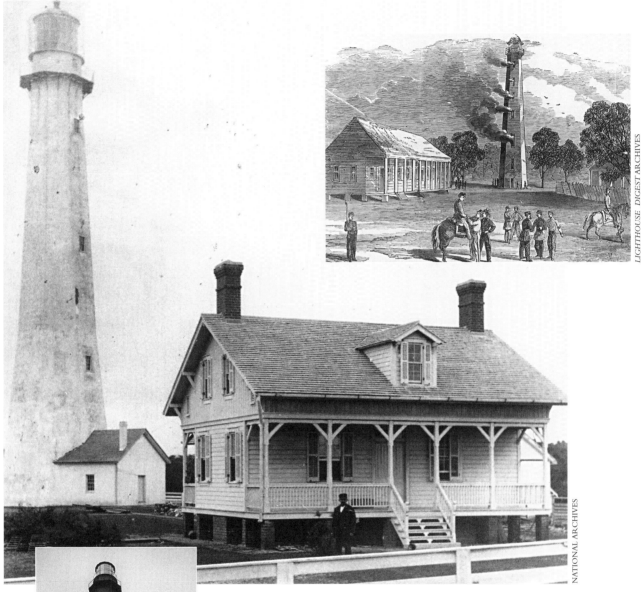

DURING THE 1730s, early Georgia settlers led by James Ogle-thorpe built an unlighted tower on Tybee Island to mark the Savannah River entrance. A brick lighthouse erected in 1772 was burned by Confederate troops as they retreated from the island early in the Civil War. The old woodcut engraving (upper right) depicts the burning, which did not completely destroy the brick tower. Following the war, the station was repaired and placed back in service. The photograph above features a late-nineteenth-century view of Georgia's Tybee Island Light. The tower was handsomely restored during the 1990s (left).

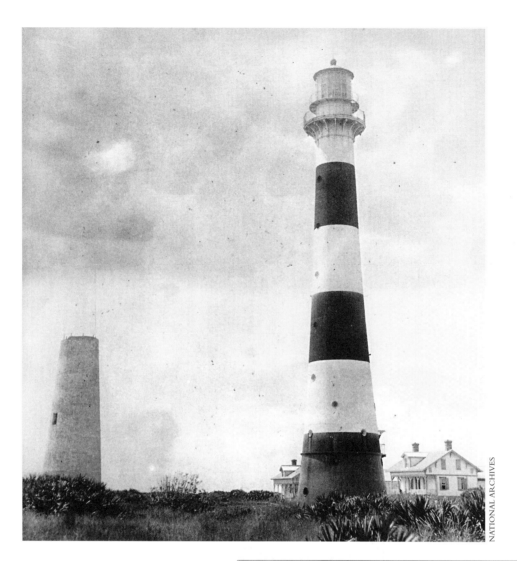

LONG BEFORE ROCKETS blasted toward space from Cape Canaveral, soaring lighthouses helped mariners avoid the cape's ship-killing sands. The ruins of a 65-foot tower built in 1848 can still be seen in the view above, along with its 145-foot replacement completed after the Civil War.

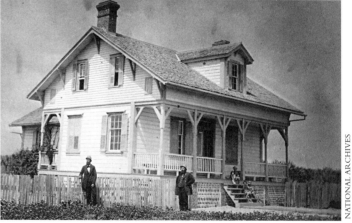

Prominent in this nineteenth-century close-up view of the station's Victorian-style residence are the keeper and a second figure, possibly a lighthouse inspector.

FLORIDA: CAPE FLORIDA LIGHTHOUSE

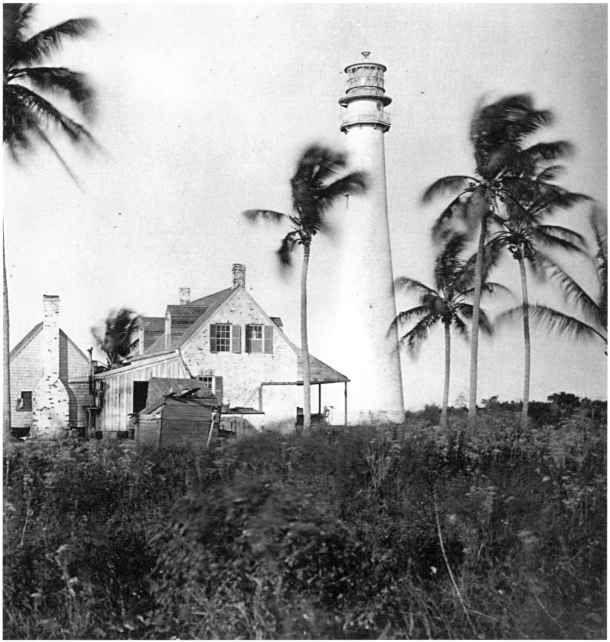

HAVING ACQUIRED FLORIDA from the Spanish in 1819, the U.S. government began to build light-houses both on the peninsula coasts and in the Florida Keys. Among the first of these was the Cape Florida Lighthouse on Key Biscayne. The station's brick tower was built like a fortress, and although raised in height at least once and refurbished several times, it still stands. This view of the station dates to 1890. Partly because of its extreme isolation and exposure to storms, the Cape Florida Lighthouse proved an especially dangerous post for keepers and their families. In 1835 a raid by Seminole warriors took the lives of the keeper's wife and children. The following year, an assistant Cape Florida keeper was killed in a similar attack.

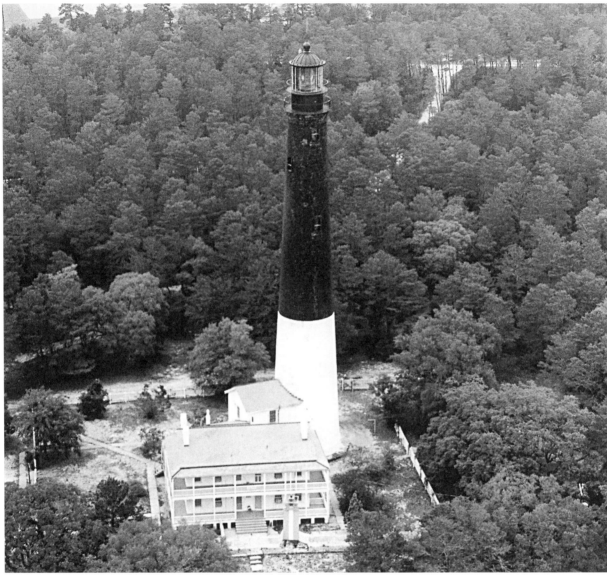

An aerial view of the Pensacola Light today.

LIKE SO MANY LIGHTHOUSES established during the first half of the nineteenth century, the original 1824 Pensacola Light tower was poorly built, and it was ill-suited to its task of guiding naval vessels to safe harbor. The mighty brick tower that took its place in 1858 is still in use (see also page 31).

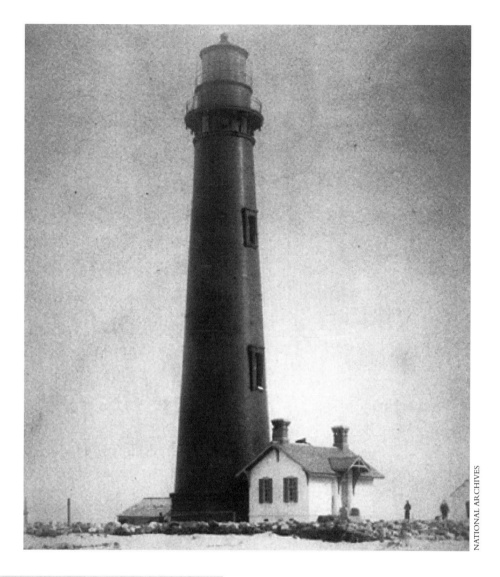

NATIONAL ARCHIVES

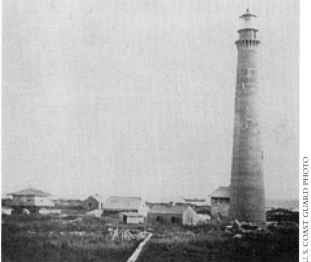

U.S. COAST GUARD PHOTO

BUILT IN 1858, Alabama's soaring Sand Island Light (below) lasted only three years. A Confederate raiding party blew it up in 1861. The existing Sand Island tower, located near the entrance to Mobile Bay, was completed in 1873. Instead of Confederate soldiers, its worst enemies proved to be hurricanes and time. A 1906 hurricane carried away the small residence shown in the photograph above, along with the keeper and his wife—their bodies were never found. Repeated storms have washed away the island, and the old tower is now in danger of collapse.

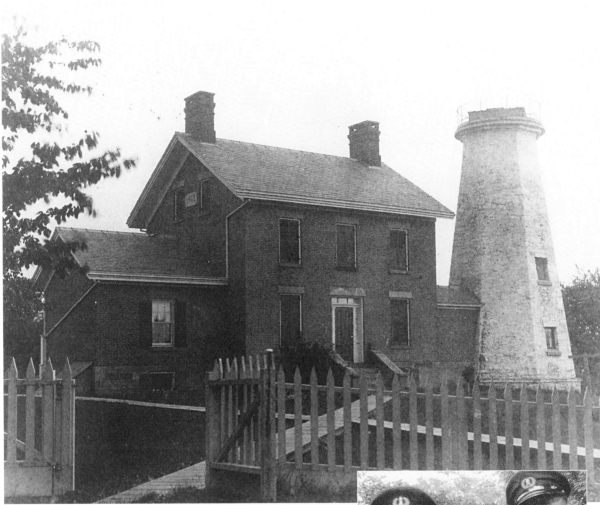

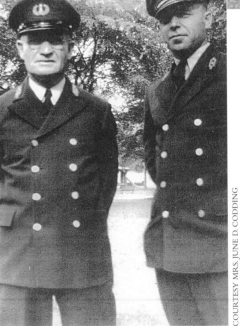

AFTER GUIDING LAKE ONTARIO SHIPPING FOR MORE THAN SIXTY YEARS, the Charlotte-Genesee Lighthouse near Rochester, New York, was closed in 1884, when a pier light tower was completed nearby. Shown empty and boarded up in this mid-twentieth-century view, the venerable structure would have been demolished except for a letter-writing campaign by local high school students that convinced Coast Guard officials to save it. During the 1980s, the station was refurbished and reactivated, and it now serves as an active aid to navigation as well as a historic attraction.

George Codding (left) and Wilbur Folwell (right) were among the last keepers of the Genesee Lights.

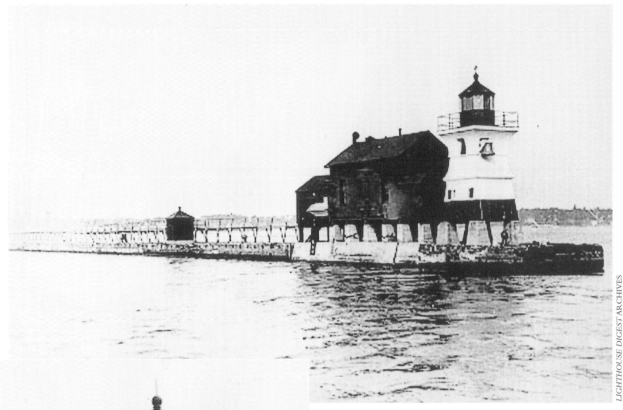

LIGHTHOUSE DIGEST ARCHIVES

(Above) The Genesee North Pier Lighthouse in Rochester Harbor was completed in 1884. Notice the fog bell hung from the side of the tower.

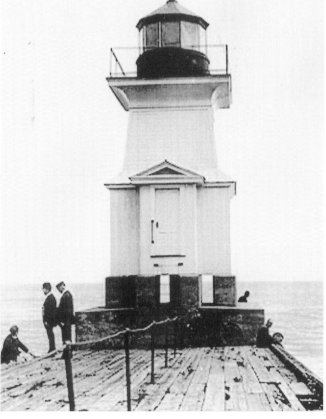

LIGHTHOUSE DIGEST ARCHIVES

The Genesee East Pier Lighthouse was built in 1902.

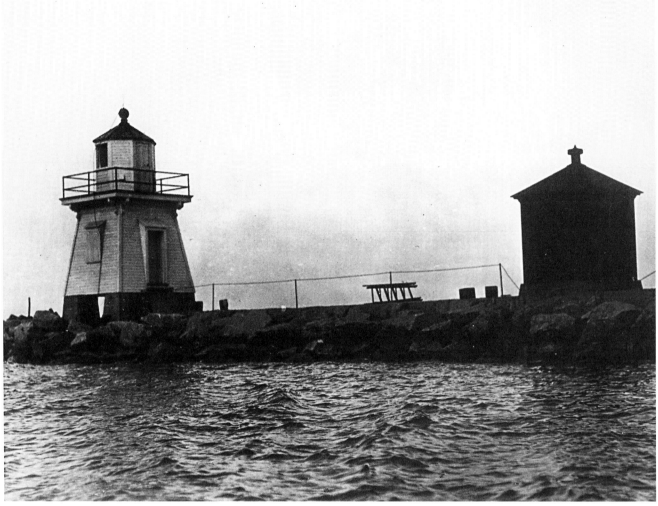

LOCATED ON OHIO'S LAKE ERIE shore, the original Port Clinton Light (right) looked more like a rough stone farmer's cottage and silo than a navigational station. Abandoned only ten years after it was completed in 1833, the structure was eventually torn down. The pier light tower shown (above) marked Port Clinton's harbor from 1896 until the 1950s, when it was moved to a local marina.

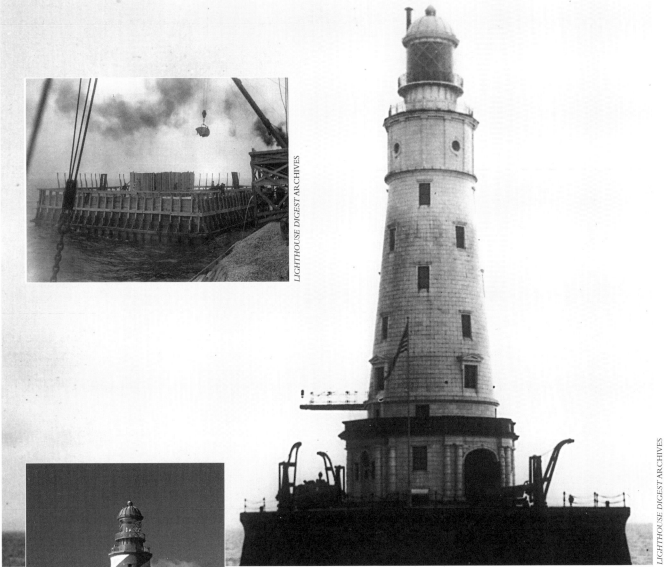

LIGHTHOUSE DIGEST ARCHIVES

LIGHTHOUSE DIGEST ARCHIVES

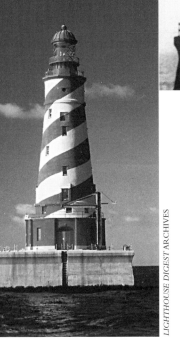

LIGHTHOUSE DIGEST ARCHIVES

CONSTRUCTION OF THE OPEN-WATER WHITE SHOAL LIGHT in 1891 proved a major feat because of the station's remote location in the far northern reaches of Lake Michigan. Workers first built a concrete platform (above left), then the brick-lined steel tower itself (right). Originally all white, the tower eventually received the barber-pole stripes that now make it one of the most distinctive structures on the Great Lakes.

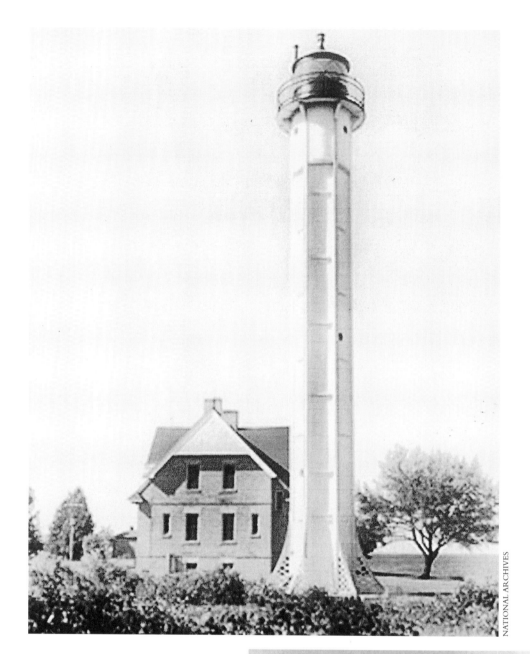

NATIONAL ARCHIVES

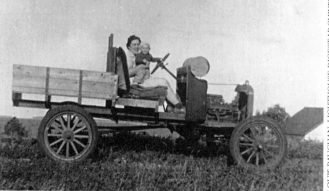

LOUIS BAUCHAN, *LIGHTHOUSE DIGEST ARCHIVES*

ALTHOUGH BUILT IN 1905, the St. Martin Island Light on the northwestern shore of Lake Michigan has a rather modern look. Its hexagonal concrete tower and fin-like supports present the appearance of a rocket about to blast off into space. In sharp contrast, the station truck, hand-built by keeper Louis Bauchan, suggests earlier times.

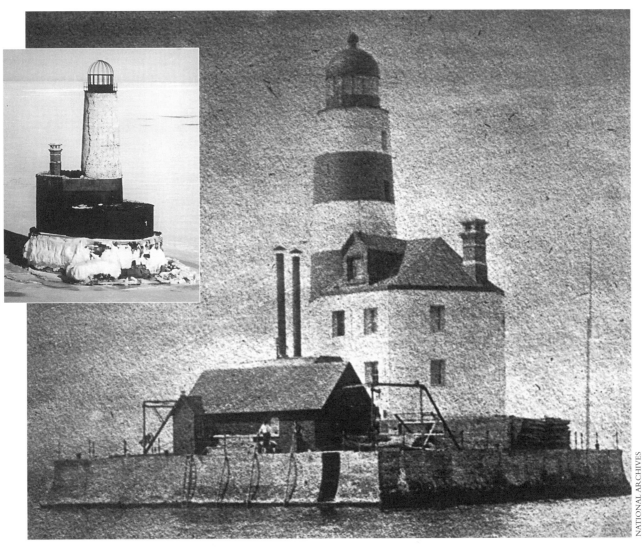

LIGHTHOUSE DIGEST ARCHIVES

NATIONAL ARCHIVES

A GRAINY, EARLY-TWENTIETH-CENTURY PHOTOGRAPH depicts the Waugoshance Light Station located off the northwestern tip of Michigan's Lower Peninsula. Built in 1851, the open-water station guided mariners until it was deactivated in 1910. During World War II, the abandoned building was used for target practice by pilots and set on fire. Only the shell of the original station remains (upper left).

COURTESY SUE AND LEO KUSCHEL

Waugoshance keeper Edward Wheaton and two assistants prepare to launch the station's life-saving boat (circa 1908).

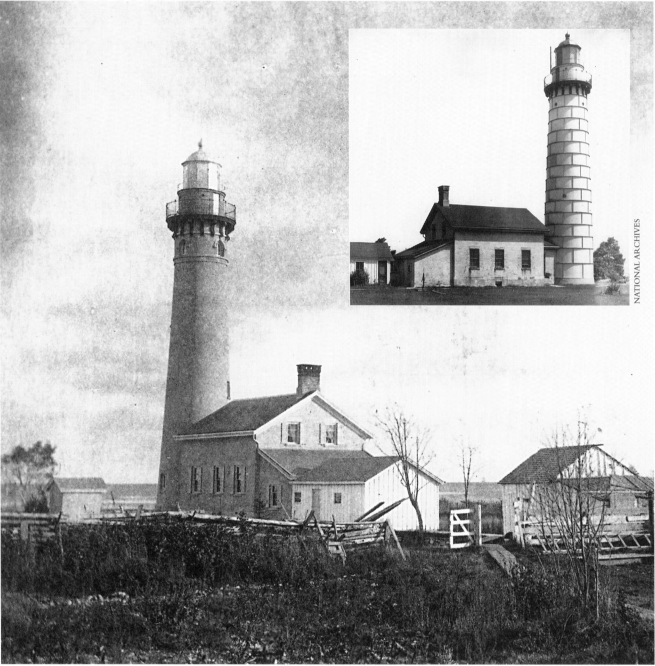

BUILT IN 1870 WITH RELATIVELY POOR QUALITY YELLOW BRICK, Wisconsin's 86-foot Cana Island tower, shown above as it originally looked, soon began to crumble. Eventually, it was armored with steel plates to protect it from Lake Michigan's harsh winter weather (inset). The station's third-order beacon still marks the northern approaches to Baileys Harbor.

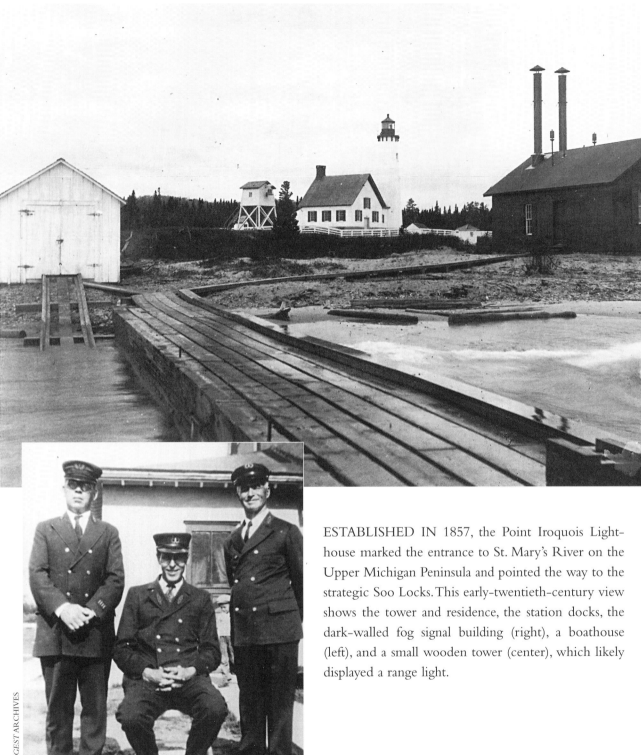

ESTABLISHED IN 1857, the Point Iroquois Lighthouse marked the entrance to St. Mary's River on the Upper Michigan Peninsula and pointed the way to the strategic Soo Locks. This early-twentieth-century view shows the tower and residence, the station docks, the dark-walled fog signal building (right), a boathouse (left), and a small wooden tower (center), which likely displayed a range light.

A 1920s photograph of Point Iroquois keeper Elmer Byrnes (left) and two assistants.

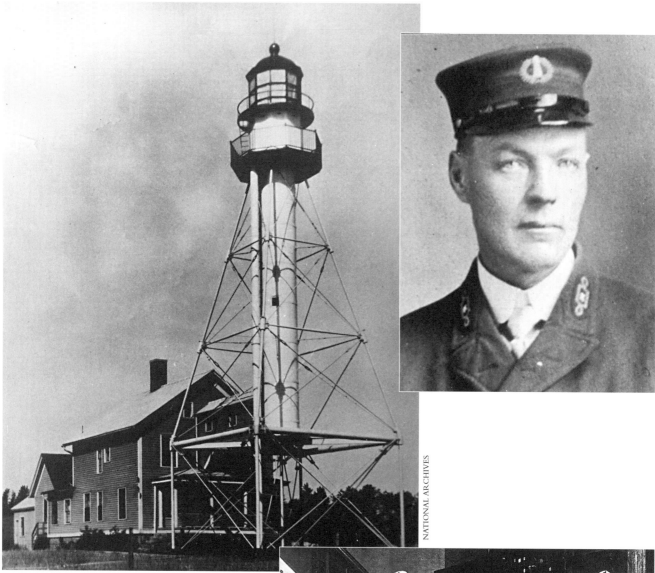

NATIONAL ARCHIVES

GREAT LAKES SHIPWRECK MUSEUM

MICHIGAN'S WHITEFISH POINT LIGHTHOUSE on Lake Superior as it looked during the 1920s when Robert Carlson (upper right) was keeper.

GREAT LAKES SHIPWRECK MUSEUM

Coast Guard keeper Sam Crozier (right) in the Whitefish Point fog signal engine room shortly before World War II.

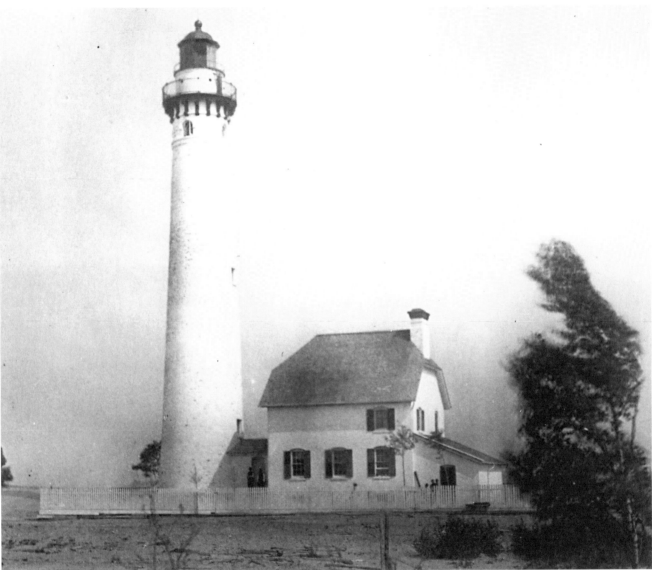

AMERICAN LIGHTHOUSE FOUNDATION ARCHIVES

MARINERS ONCE DREADED the dark shoreline west of Whitefish Point on the Upper Michigan Peninsula. Completed in 1874, the Au Sable Point Lighthouse helped make this dangerous coast much safer for ships. The tower and dwelling have changed little during the century since this photograph was taken.

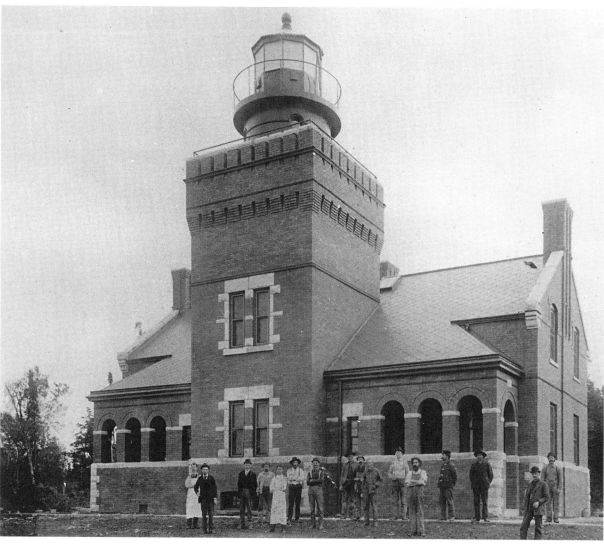

AN UNKNOWN GROUP poses in front of Michigan's Fourteen Mile Point Lighthouse. Perhaps these are the masons, carpenters, and laborers who built the lighthouse in 1894. The fourth man from the right is wearing a Lighthouse Service uniform and is likely the station's keeper. The Fourteen Mile Point beacon warned mariners to keep their distance from a rugged stretch of the Keweenaw Peninsula on Lake Superior. Automated in 1934, the light was extinguished about twenty years later. At right, the ruined station after it was burned by vandals in 1984.

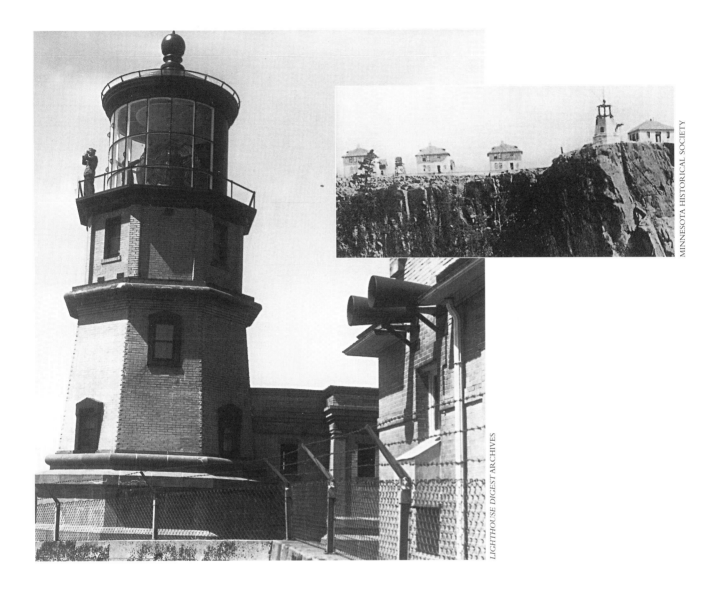

LIGHTHOUSE DIGEST ARCHIVES

MINNESOTA HISTORICAL SOCIETY

POISED AT THE EDGE OF A CLIFF over-looking mighty Lake Superior, Minnesota's Split Rock Lighthouse can boast one of America's grandest settings. Although its beacon has been inactive since 1969, the station continues to serve the public as a museum, educational fac-ility, and principal attraction of Minnesota's Split Rock State Park. The photograph above shows the lighthouse during the 1940s when Great Lakes ore freighter traffic reached its peak. The photo-graph at lower right shows the station under con-struction in 1910.

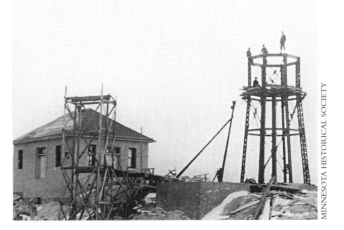

MINNESOTA HISTORICAL SOCIETY

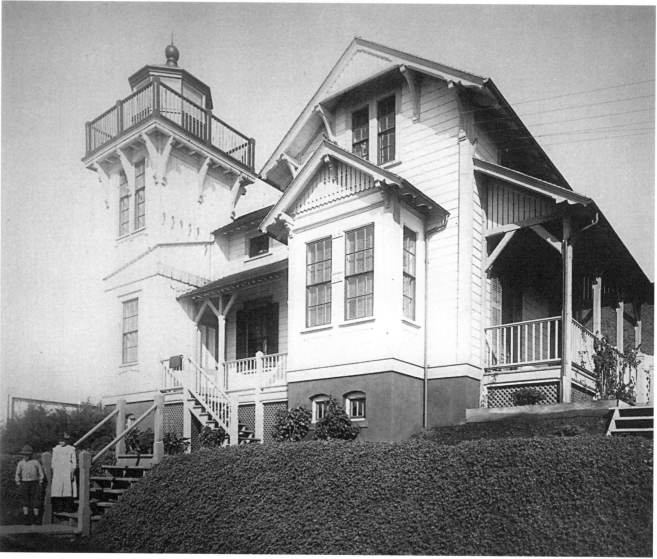

THE SAN LUIS OBISPO LIGHT must have been a wondrous place for children. Built in a Victorian design similar to that of several other California lighthouses, it was covered in decorative gingerbread and had plenty of nooks and crannies. Completed in 1890, the station was deactivated in 1975.

A pair of boiler stacks rise from the fog signal building.

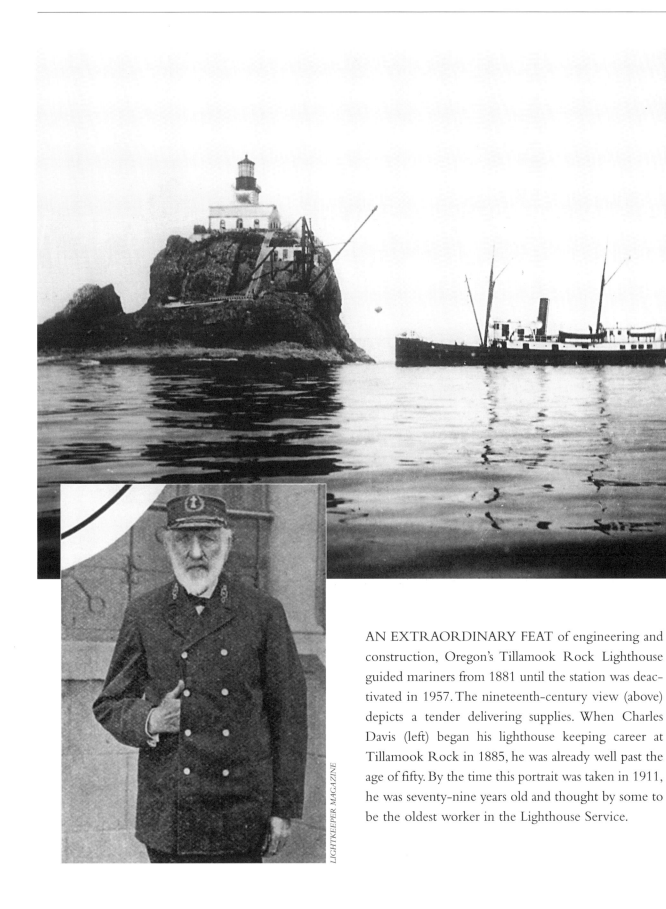

NATIONAL ARCHIVES

LIGHTKEEPER MAGAZINE

AN EXTRAORDINARY FEAT of engineering and construction, Oregon's Tillamook Rock Lighthouse guided mariners from 1881 until the station was deactivated in 1957. The nineteenth-century view (above) depicts a tender delivering supplies. When Charles Davis (left) began his lighthouse keeping career at Tillamook Rock in 1885, he was already well past the age of fifty. By the time this portrait was taken in 1911, he was seventy-nine years old and thought by some to be the oldest worker in the Lighthouse Service.

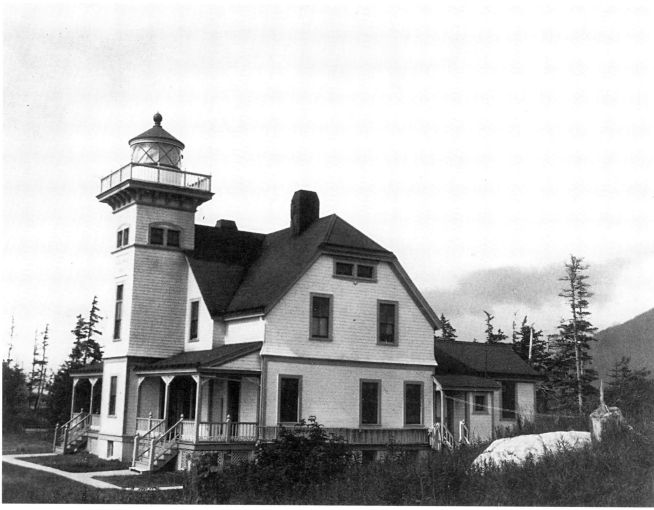

ESTABLISHED IN 1902, the Sentinel Island Light Station near Juneau, Alaska, originally consisted of a two-story wood-frame residence with an attached square tower. The building shown here was torn down in 1935 and replaced by a reinforced concrete structure.

THE END OF THE GOLDEN AGE

The Last Days of the Lighthouse Service

THE GOLDEN AGE OF LIGHTHOUSES STARTED TO END almost as soon as it had begun. The same spirit of modernism and innovation that had launched this classic period during the 1850s would become its undoing. As time passed, improvements in navigational technology made it easier, less expensive, and more practical to guide mariners without towers, lantern rooms, lenses, or keepers, which is to say without lighthouses. Automated channel markers, radio beacons, radar, and other shipboard navigational equipment eventually made lighthouses all but obsolete.

The automation of lighthouse beacons begun by the U.S. Lighthouse Service and continued by the U.S. Coast Guard at a more rapid pace finally closed the door on the golden age. By definition, a house is a place where people live. So once keepers where removed from light stations, they could no longer be considered true light "houses." What was worse, without keepers to maintain them, the old light stations quickly deteriorated. Many fell into ruins and had to be torn down. Others only now are being restored to their former glory.

For the purposes of this book, the golden age came to an end in 1939, when President Franklin D. Roosevelt dissolved the old Lighthouse Service and handed responsibility for navigational beacons over to the Coast Guard. This should not be seen as any sort of slight to the brave men and women of the Coast Guard who have always done their duty in exemplary fashion and continue to do so today. However, since the Coast Guard is entrusted with the safety of mariners and of public waterways, the maintenance of historical properties is not its primary mission.

Fortunately, today many lighthouses are being passed along to state and local governments and private groups who are in a better position to care for them. Some have been handsomely refurbished, and many attract a steady stream of visitors. Perhaps the current renewal of interest in maritime history in general and our nation's grand old light towers in particular can be seen as the beginning of a new and different sort of golden age.

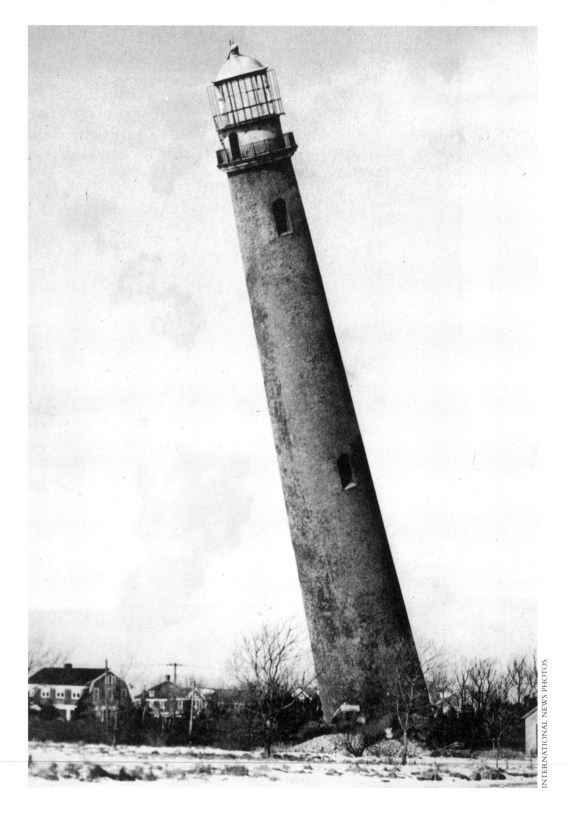

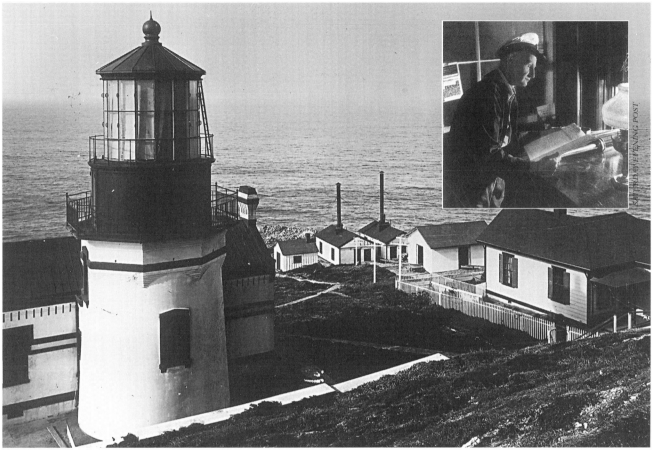

U.S. COAST GUARD PHOTO

SATURDAY EVENING POST.

SATURDAY EVENING POST

ESTABLISHED WHEN GOLD PROSPECTORS still scoured the California hills in hopes of striking it rich, the Point Conception Light Station has guarded California's southwestern "horn" since 1856. The existing tower was built in 1882 following destruction of the original lighthouse in the great Fort Tejon earthquake. In the view above curtains have been drawn to protect the delicate Fresnel lens from the sun. Important daily chores of this sort were left undone after the beacon was automated and the last keepers were removed from the station in 1973. However, the old ways continued much longer at isolated Point Conception than at most other lighthouses. The 1946 photograph at left shows Gene Lester stubbornly wearing his Lighthouse Service cap more than seven years after the agency was absorbed by the U.S. Coast Guard. When the Coast Guard took over in 1939, Lester decided to remain with the station as a civilian employee. So, too, did his assistant keeper, Charley Hellwig, shown in the inset at upper right keeping the station log by the light of a kerosene lamp. During the 1940s, Point Conception still had no electricity or telephone, and the keepers entertained themselves with music from a hand-cranked phonograph.

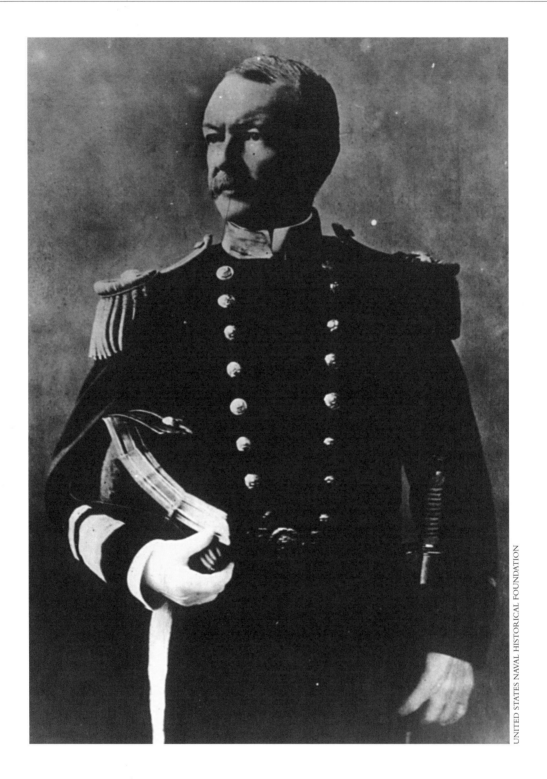

UNITED STATES NAVAL HISTORICAL FOUNDATION

THE U.S. LIGHTHOUSE SERVICE was largely a product of the nineteenth century and of stalwart individuals like Rear Admiral Francis J. Higgins, who was chairman of the Lighthouse Board when the twentieth century dawned.

GEORGE PUTNAM, LIGHTHOUSE COMMISSIONER

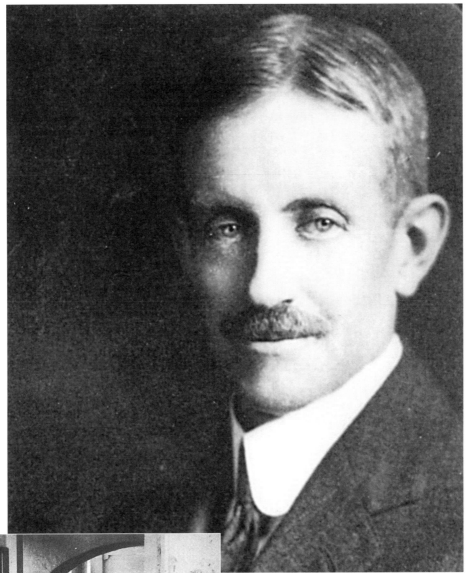

COURTESY MRS. JOHN HAY

COURTESY MRS. JOHN HAY

IN 1910 CONGRESS shifted responsibility for administering the nation's navigational aids away from the Lighthouse Board and placed it in the hands of a commissioner. George Putnam (above), formerly the director of the coast survey in the Philippine Islands, was named the first commissioner of lighthouses, a position he held for twenty-five years. Putnam did much to modernize the Lighthouse Service. Putnam is shown at left at work in the Philippines.

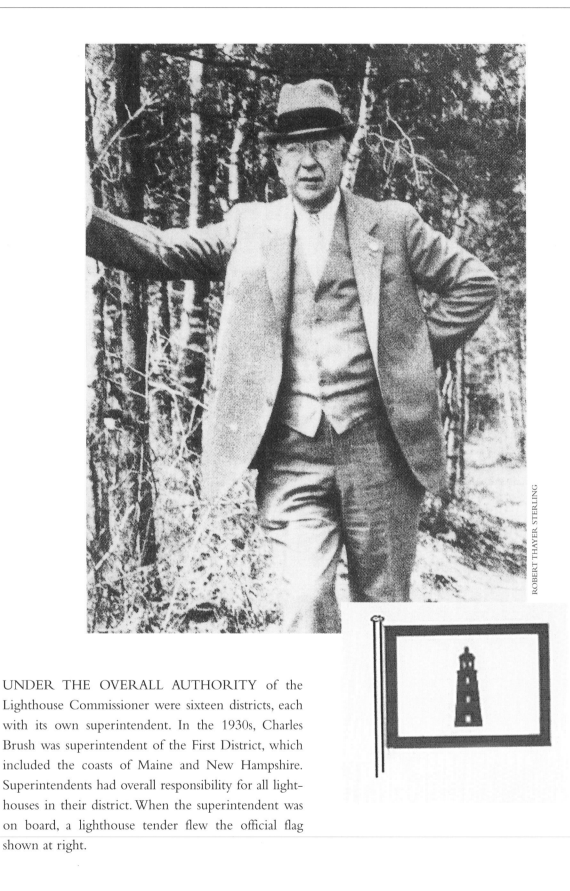

ROBERT THAYER STERLING

UNDER THE OVERALL AUTHORITY of the Lighthouse Commissioner were sixteen districts, each with its own superintendent. In the 1930s, Charles Brush was superintendent of the First District, which included the coasts of Maine and New Hampshire. Superintendents had overall responsibility for all light-houses in their district. When the superintendent was on board, a lighthouse tender flew the official flag shown at right.

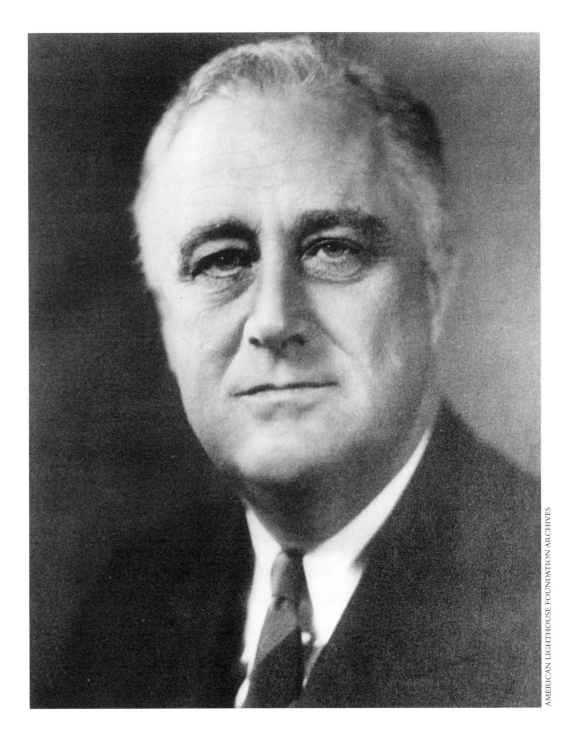

AMERICAN LIGHTHOUSE FOUNDATION ARCHIVES

IN 1939 PRESIDENT FRANKLIN DELANO ROOSEVELT decided to dissolve the Lighthouse Service and pass its responsibilities along to the U.S. Coast Guard. Historians believe Roosevelt's reasons for doing this were largely strategic. With war descending on Europe and the United States likely to become embroiled at some point, he thought it prudent to place the nation's coastal beacons and other navigational aids in the hands of a military organization.

WILLIAM DEMERITT

FEW SHARED PRESIDENT ROOSEVELT'S LONG-RANGE STRATEGIC VISION, and many strongly disagreed with his decision to dissolve the Lighthouse Service. Among the president's more vocal opponents was William Demeritt, superintendent of the Seventh District and keeper of the Key West Lighthouse. During a presidential visit to Key West, Florida, in 1939, Demeritt confronted Roosevelt, and the two men engaged in a fist-shaking debate. Not surprisingly, Demeritt lost the argument. Demeritt is shown above with his family on the steps of the Key West keeper's residence.

COMMISSIONER H.D. KING AND
COMMANDANT RUSSELL WAESCHE

AMERICAN LIGHTHOUSE FOUNDATION

COURTESY EDITH KING

THE LAST COMMISSIONER of the U.S. Lighthouse Service was H.D. King, pictured on the left with his wife and daughter. In 1939 King handed authority over America's extensive system of lighthouses and other navigational aids to U.S. Coast Guard Commandant Russell Waesche (above).

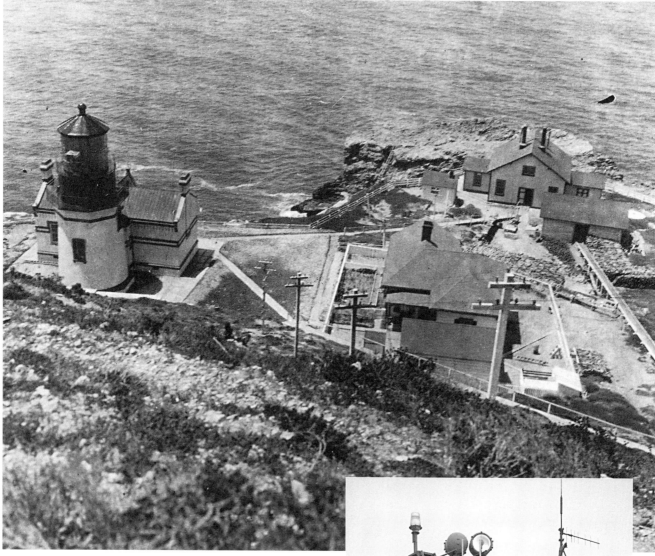

THE PRAGMATIC APPROACH made necessary by tight Coast Guard budgets was to have a profound impact on many historic light stations. In 1856 the Lighthouse Board ordered construction of a lighthouse on the remote Farallon Islands about 20 miles west of San Francisco. Interestingly, the station already had electricity by the time the photograph above was taken in 1915. Eventually, technology would make the station all but unrecognizable as a lighthouse. In 1972 the lantern was removed from the tower to make way for an automated rotating beacon (right).

SHINNECOCK LIGHT

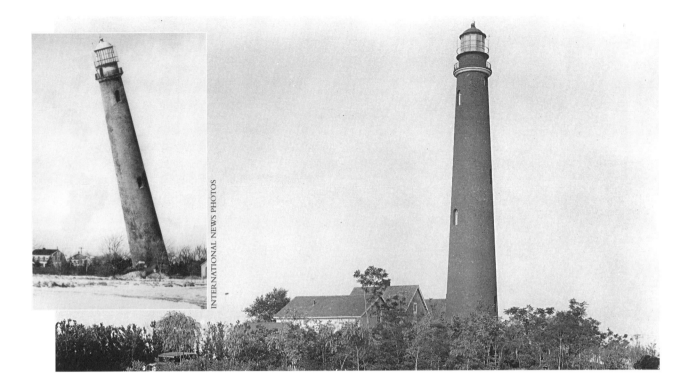

INTERNATIONAL NEWS PHOTOS

IN 1857 A GIANT LIGHTHOUSE was built on Ponquogue Point beside New York's Shinnecock Bay. It took more than a million bricks to complete the tower, which at 170 feet was once one of the tallest structures in the United States. The beacon that flashed seaward from the top of the immense tower guided several generations of mariners. By the 1930s, however, the light was no longer needed, and it was taken out of service. Following World War II, the Coast Guard decided to demolish the unused lighthouse to make way for an administrative center and parking lot. Local citizens objected to the plan, but to no avail. Three days before Christmas in 1948, a demolition crew undercut the tower's foundation and the seventeen-story structure came thundering down. Perhaps the unhappy fate of the Shinnecock titan can be seen as symbolic of the end of the golden age of lighthouses. For a local journalist named John Sutter, the destruction of the tower had meaning that could only be expressed in poetry. Having witnessed the tower's fall, he wrote these words:

For many years I used to sit and watch from out my window,
The flashing of a great light that set my heart aglow.
And I knew that far at sea ships that would pass by,
Could see that flashing light the same as you or I.

Then came the day when word went out that its job was done,
And its light would be dimmed at the rising of the sun.
They said that it was dangerous and might tumble down,
Yet it stood a mighty hurricane from its foot up to its crown.

But now the great light is no more, gone beyond recall.
We did our best and with tears we watched it fall.
Good for another hundred years, that's what the debris showed,
But all we have is the memory of when the Ponquogue Light glowed.

INDEX

About the Authors

TIM HARRISON is the publisher and editor of *Lighthouse Digest* magazine, co-founder of Lighthouse Depot in Wells, Maine, co-author of several lighthouse books including *Lost Lighthouses*, and president of the American Lighthouse Foundation, a nonprofit group dedicated to saving lighthouses and their history.

RAY JONES is the text author of *American Lighthouses* and eight books in Globe Pequot's colorful Lighthouses Series. He is also co-author of *Lost Lighthouses* and *Endangered Lighthouses* as well as *Legendary Lighthouses* and *Legendary Lighthouses Volume II,* companions to the popular PBS series.